St. Marys Ontario Book 3 in Colour Photos, Saving Our History One Photo at a Time

Photography
by Barbara Raué
2015

Series Name:
Cruising Ontario

Book 131: St. Marys Book 3

Cover photo: 12 Water Street South, the Opera House, Page 52

Series Name: Cruising Ontario
Saving Our History One Photo at a Time in colour photos

Books Available in Alphabetical Order:
Aberfoyle, Acton, Alton, Ancaster, Arthur, Aylmer, Ayr, Bloomingdale, Brantford, Burlington, Caledon, Caledonia, Cambridge, Clifford, Conestogo, Delhi, Dorchester to Aylmer, Drayton, Drumbo, Dundas, Eden Mills, Elmira, Elora, Fergus, Guelph, Hagersville, Hamilton, Hanover, Harriston, Hespeler, Jarvis, Kitchener, Linwood, Listowel, London, Lucknow, Mono, Mount Forest, Neustadt, New Hamburg, Niagara-on-the-Lake, Oakville, Orangeville, Orillia, Owen Sound, Palmerston, Peterborough, Port Elgin, Preston, Rockwood, Seaforth, Sheffield, Shelburne, Simcoe, Southampton, St. Jacobs, St. Thomas, Stoney Creek, Stratford, Tillsonburg, Waterdown, Waterford, Waterloo, Wellesley, Wingham

Book 110: Lucknow, Mitchell
Book 111: Conestogo, Bloomingdale
Book 112: Delhi
Book 113: Waterford
Book 114-116: Waterloo
Book 117-119: Windsor
Book 120-121: Amherstburg
Book 122: Essex
Book 123-124: Kingsville
Book 125-127: Woodstock
Book 128: Thamesford
Book 129-132: St. Marys

Other Books by Barbara Raue

Coins of Gold

Arrows, Indians and Love

The Life and Times of Barbara
Volume 1: Inventions That Have Enhanced My Life
Volume 2: Entertainment That I Have Enjoyed
Volume 3: East Coast Trips
Volume 4: Olympics Have Always Intrigued Me
Volume 5: Wonders of the World
Volume 6: Caribbean Cruises We Have Enjoyed
Volume 7: Animals
Volume 8: Storms and Other Major Disasters in My Lifetime
Volume 9: Wars, Terrorist Attacks and Major Disasters

The Cromwell Family Book

Laura Secord Discovered

Daddy Where Are You?

Visit Barbara's website to view all of her books
http://barbararaue.ca

Table of Contents

Robinson Street — Page 6

Station Street — Page 13

Thomas Street — Page 16

Tracy Street — Page 24

Water Street North — Page 30

Water Street South — Page 37

Architectural Terms — Page 54

Building Styles — Page 58

St. Marys, known as Stonetown, is set in a beautiful valley beside the majestic Thames River. It is a town in southwestern Ontario located southwest of Stratford. St. Marys' early economic success depended on the mills powered by the water in this river.

From stunning architecture to picturesque views, St. Marys has a special character all of its own.

In 1858, the Grand Trunk Railway reached the small village of St. Marys from Toronto. The line went west to Sarnia and then, on the other side of the border, from Port Huron to Chicago. When the railway builders arrived in St. Marys in the mid-1850s, the major challenge for both structural engineers and contractors was the erection of two high railway bridges. One was needed to cross the Thames River. The other took a spur line to London across Trout Creek. Both required a row of massive stone pillars to support the girders and tracks. These became landmarks in St. Marys and are still known as the Sarnia Bridge and the London Bridge. Today, VIA Rail continues to operate the line to London while the line to Sarnia was abandoned in 1989. In 1995, the Town of St. Marys purchased the Sarnia Bridge from the Canadian National Railway. The old railway line was transformed into a walking trail for everyone to enjoy.

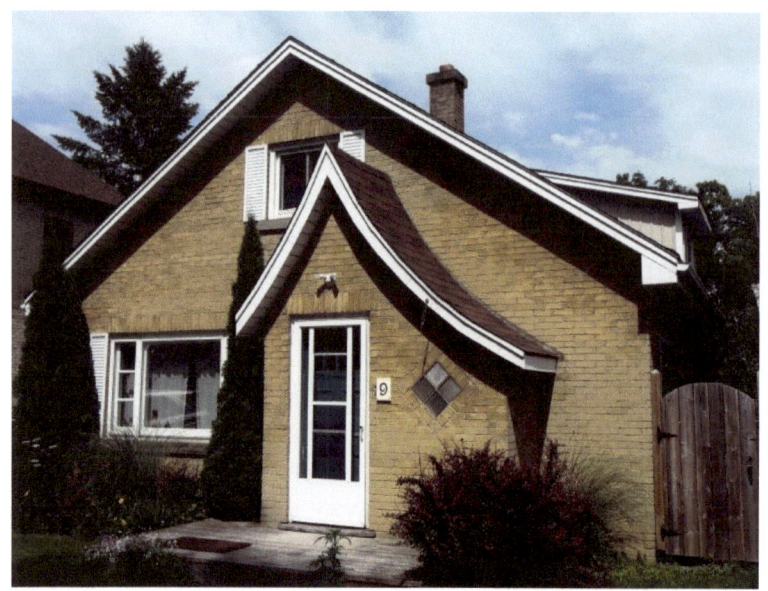

9 Robinson Street – vernacular, sidelights

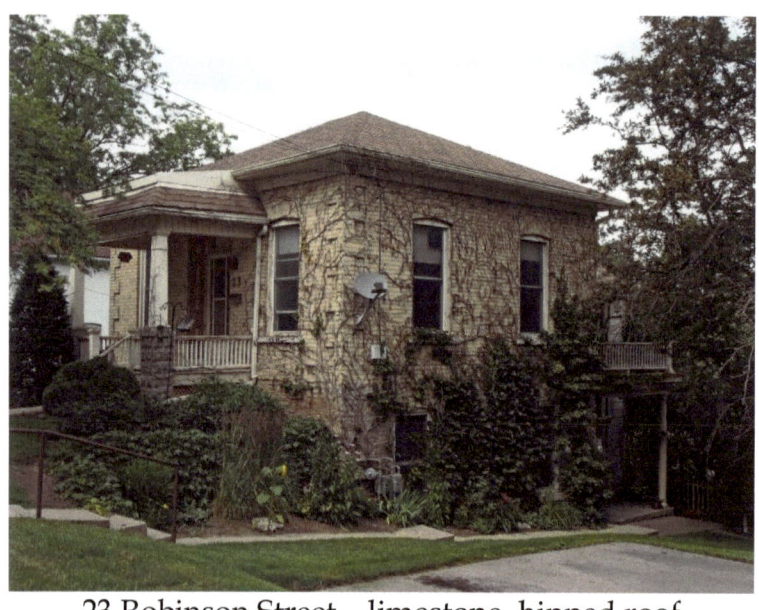

23 Robinson Street – limestone, hipped roof

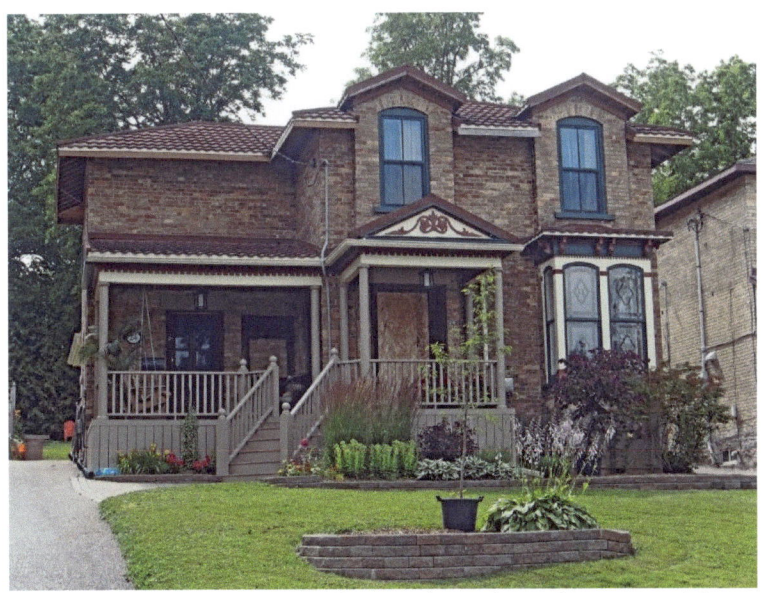

24 Robinson Street – hipped roof, pediment with decorated tympanum

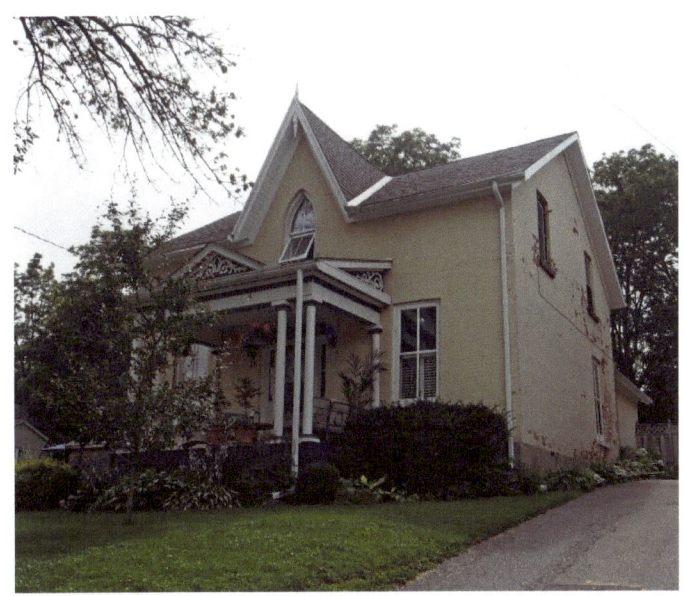

18 Robinson Street – Gothic Revival, finial on gable

13 Robinson Street – bay window with iron cresting around second floor balcony

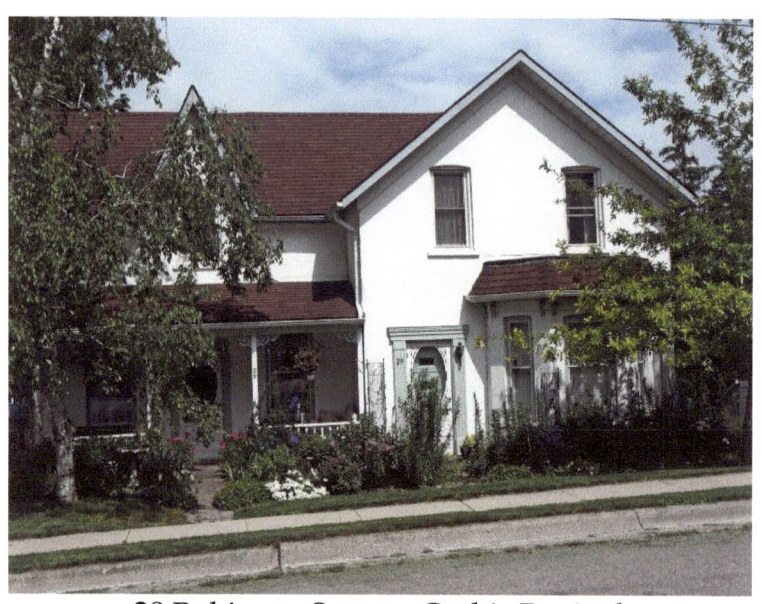

29 Robinson Street – Gothic Revival

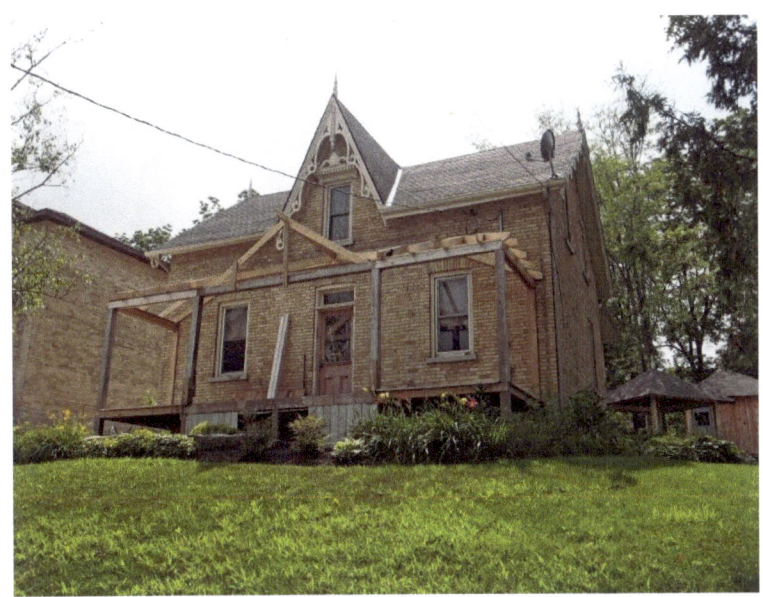

Robinson Street – Gothic Revival – verge board trim and finial on gable

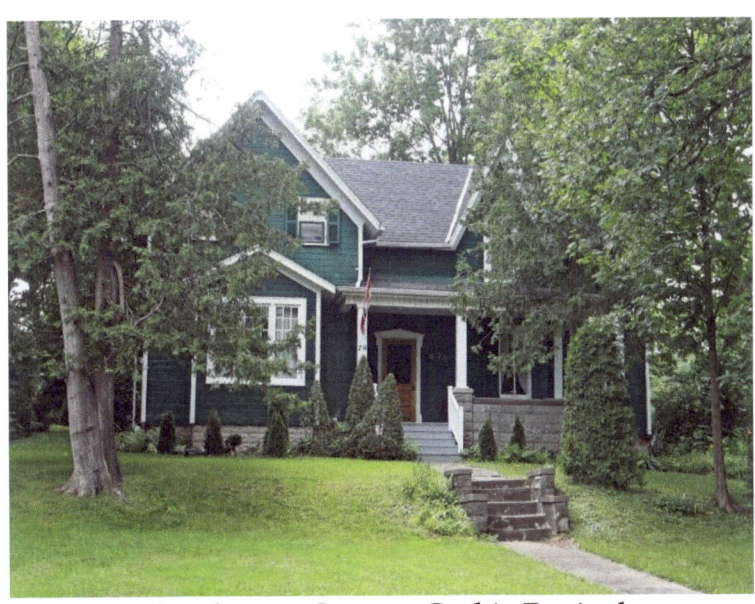

78 Robinson Street – Gothic Revival

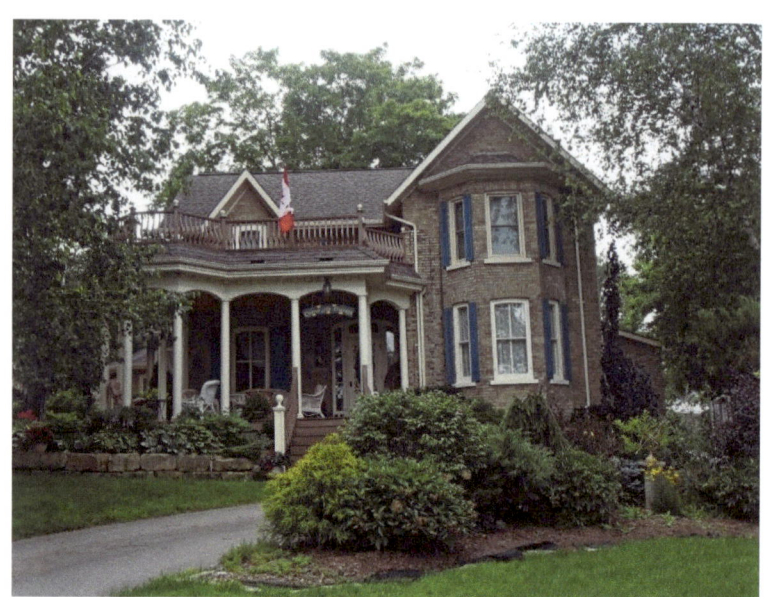

96 Robinson Street - built around 1875 for Leon Clench and his wife Eunice Cruttenden. It is now the Riverside Bed and Breakfast. Clench was a lawyer, a builder, inventor, violin-maker, musician and furniture-maker. Italianate style

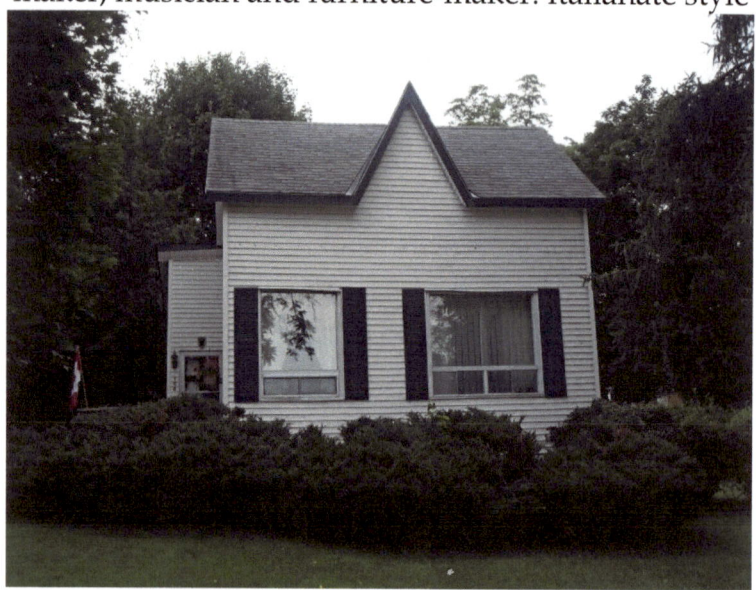

104 Robinson Street - Gothic

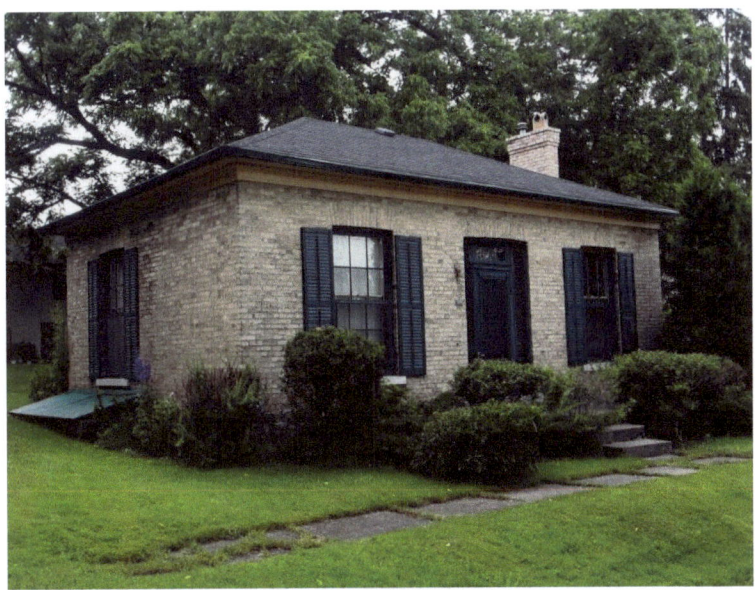

108 Robinson Street – Regency Cottage – hipped roof, built in the early 1870s for retired Irish farmer John Henry Clark

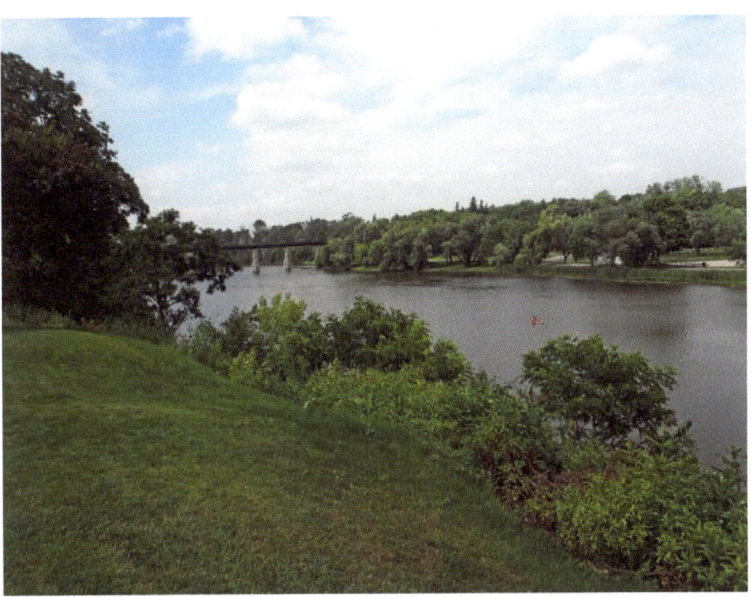

Thames River with Sarnia Bridge in background

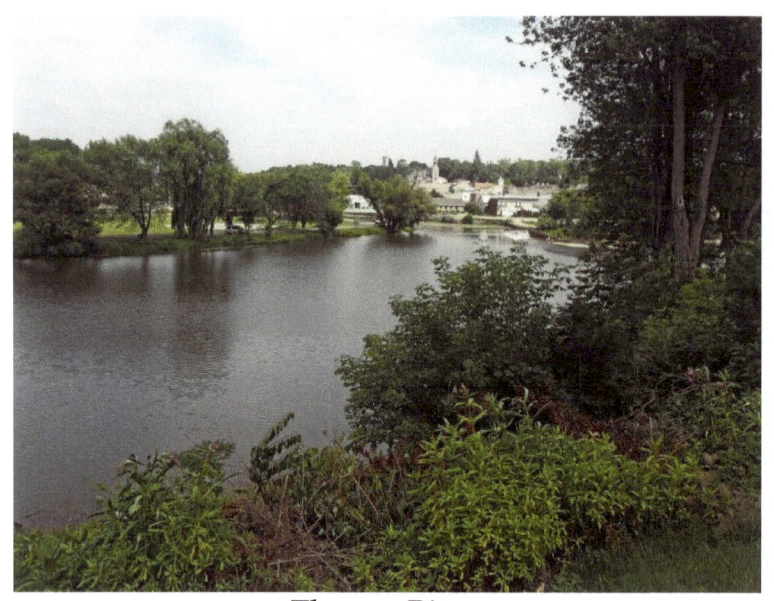
Thames River

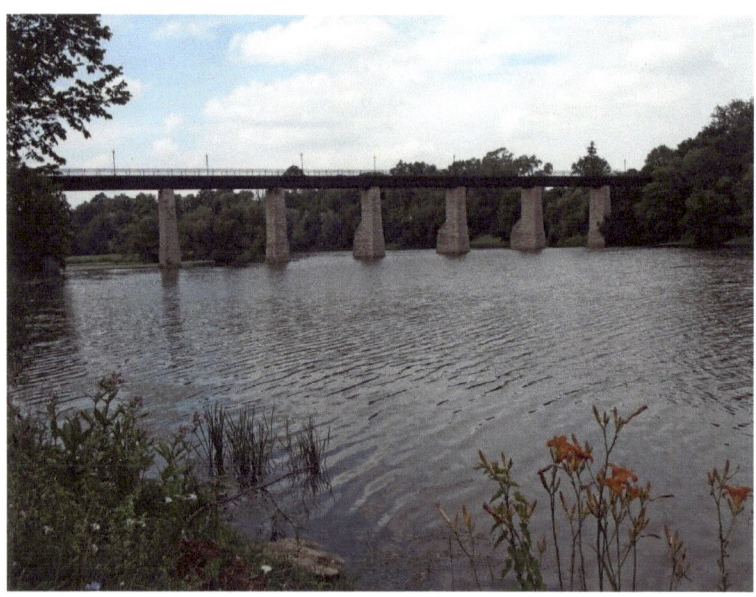
Sarnia Bridge

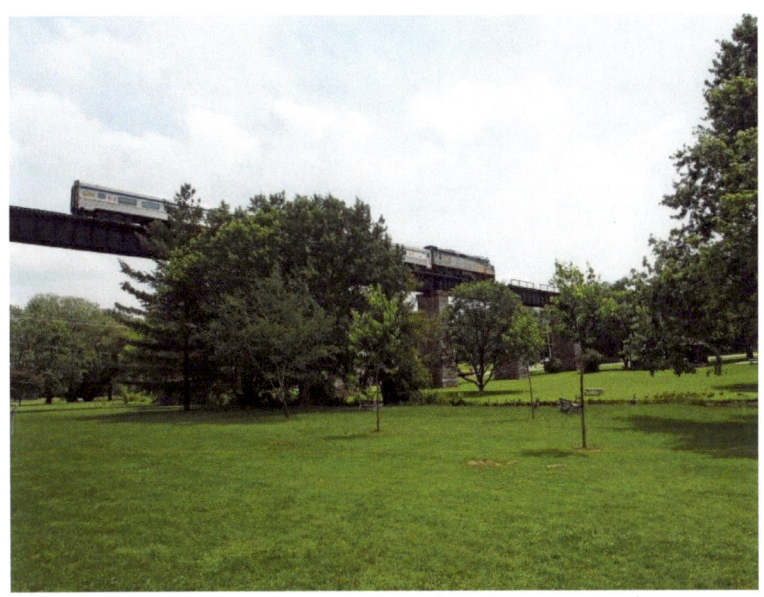

Train passing overhead at Rotary Park

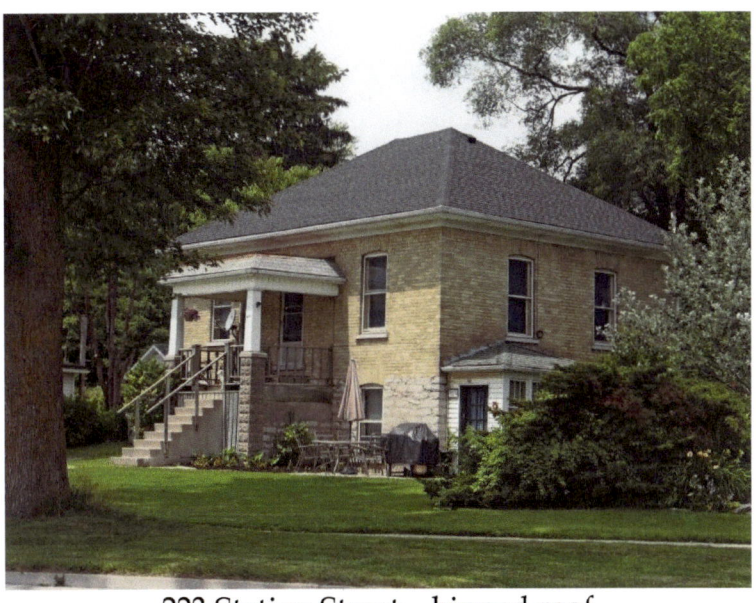

223 Station Street – hipped roof

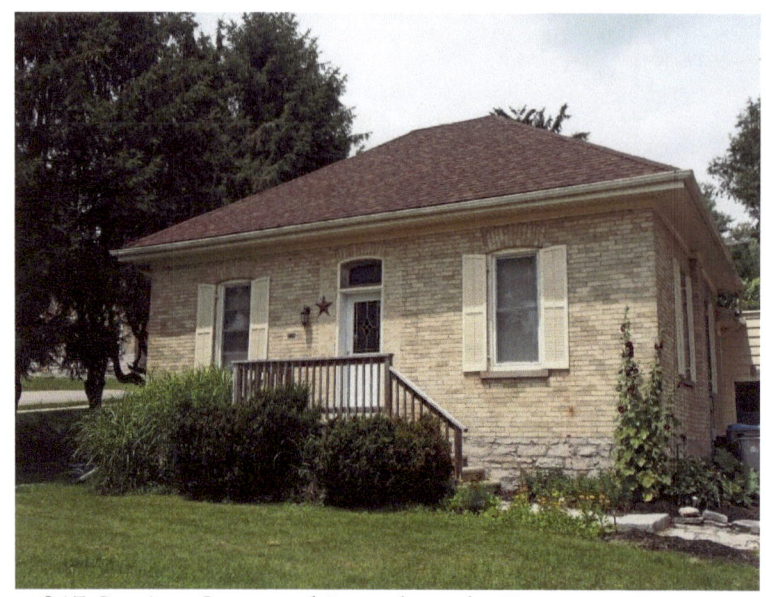

215 Station Street – hipped roof – Regency Cottage
Transom window above door

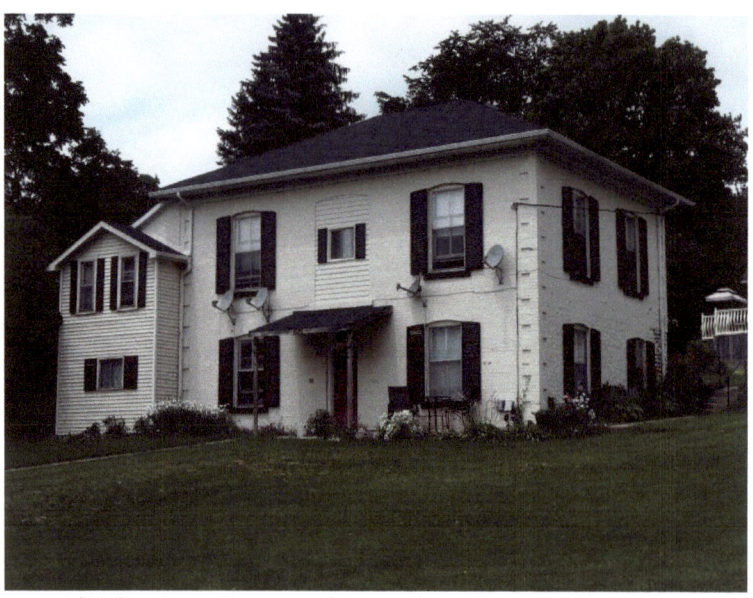

195 Station Street – hipped roof, corner quoins

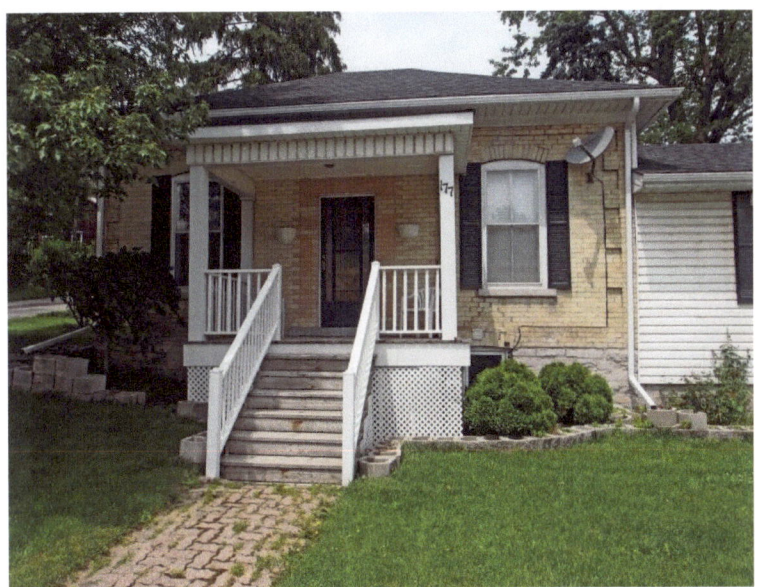

177 Station Street – corner quoins, dichromatic brickwork around front door

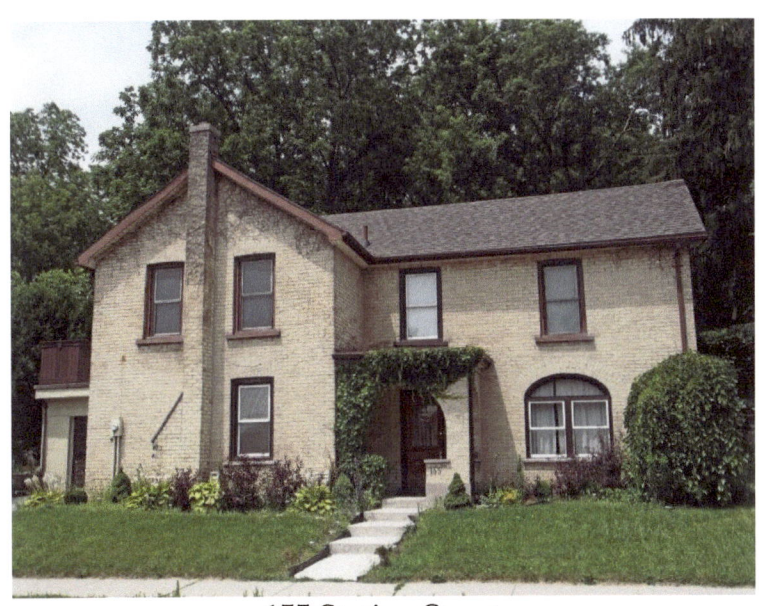

155 Station Street

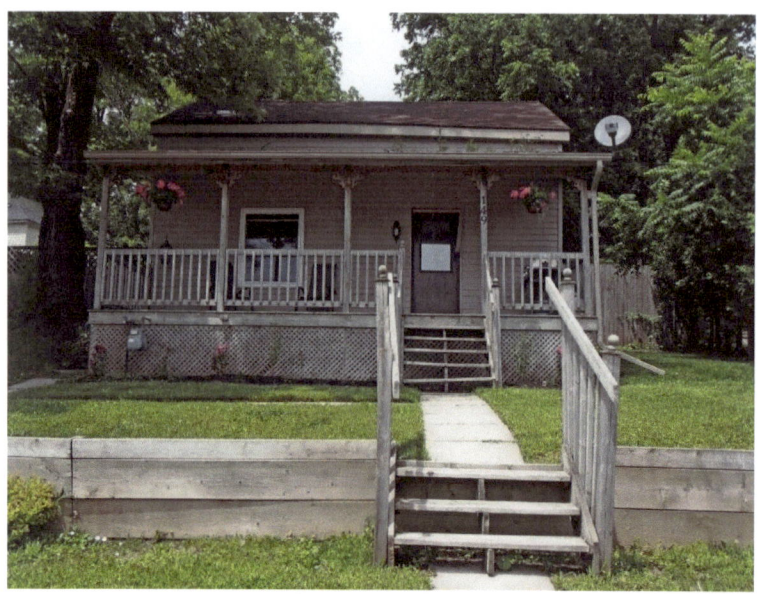

149 Station Street

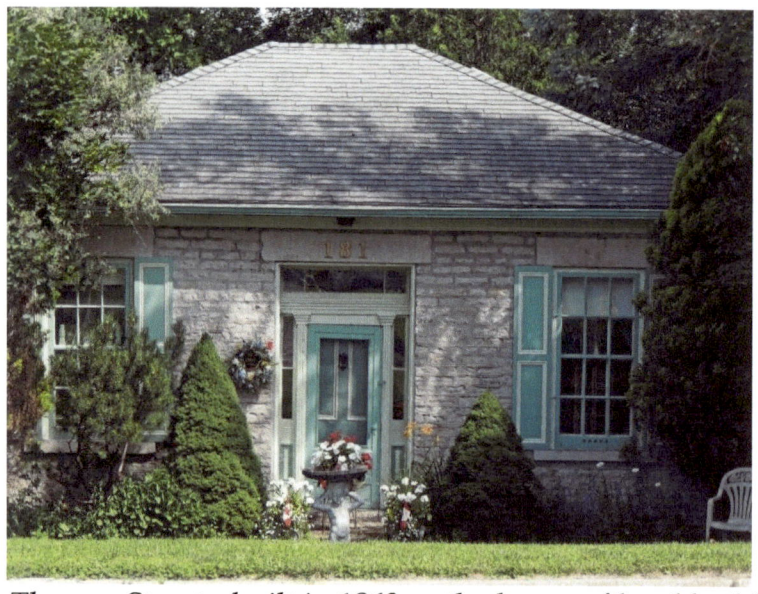

181 Thomas Street - built in 1863 as the home of local builders Alexander Grant and his son John – sidelights, transom

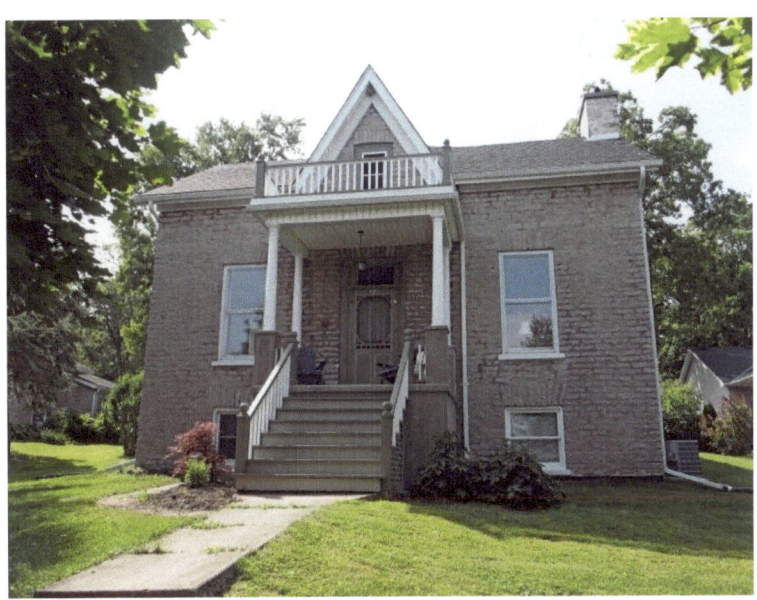

210 Thomas Street – 1865 - Local architect and builder Robert Fulton Barbour built this house in 1884 as his home. Gothic, second floor balcony

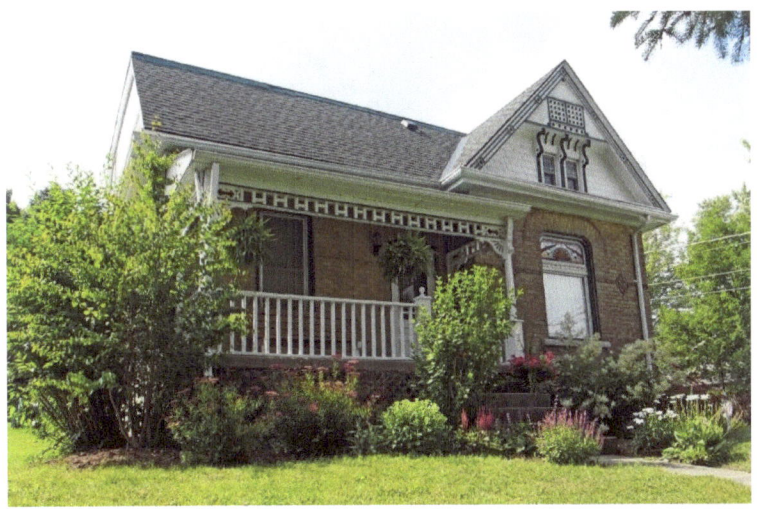

232 Thomas Street – decorative gable, stained glass window

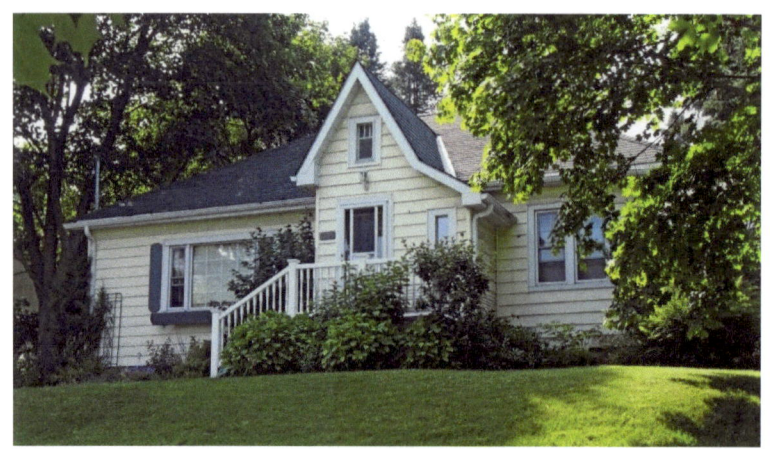

244 Thomas Street

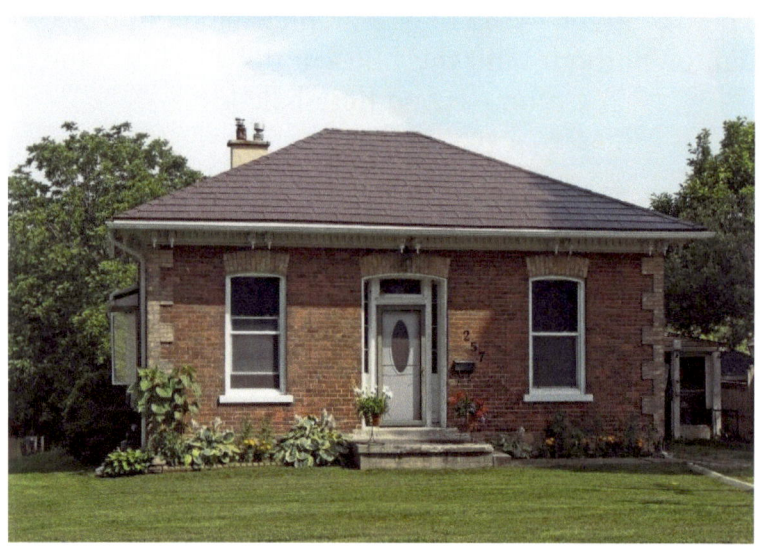

257 Thomas Street – Regency Cottage – corner quoins, paired cornice brackets, sidelights and transom windows around door

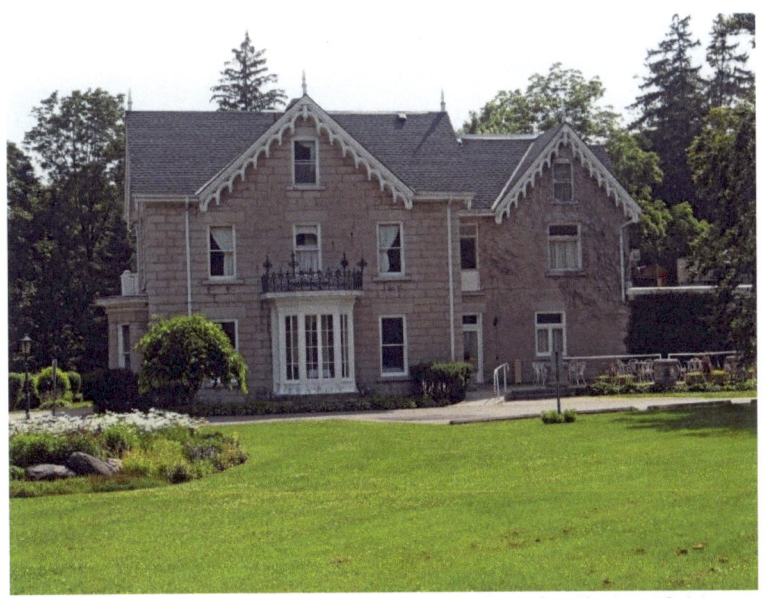

300 Thomas Street – Westover Inn built in 1864
Iron cresting above bay window,
verge board trim on gables with finials

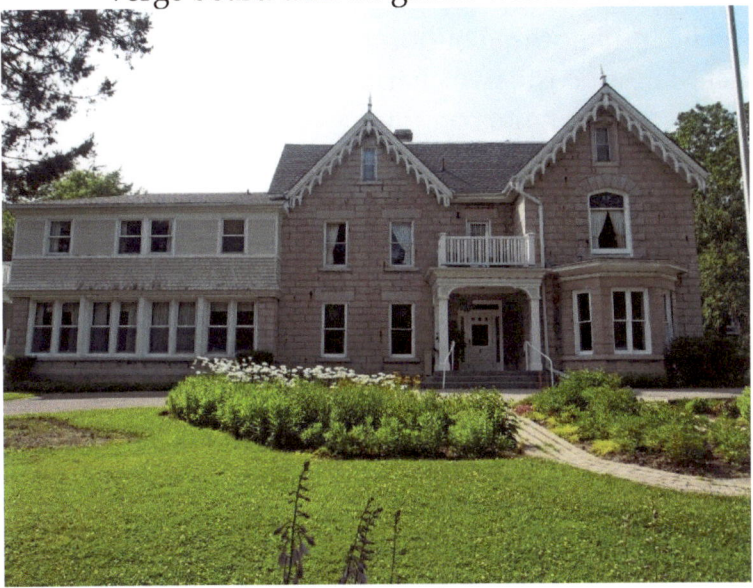

Second floor balcony above entrance

William and Joseph Hutton were the original owners of the Victorian limestone mansion. The Hutton brothers built the main house, now called the Manor, along the Thames River. It was surrounded by nineteen acres of land with seven acres cultivated.

The Roman Catholic Church acquired the estate in the 1930s and operated it as a seminary. It was during this period that the red brick dormitory with twenty-two small rooms was built off the main house. During the 1970s the seminary was sold to a group of families experimenting with communal living. The property was purchased in 1985 and twenty months were spent renovating the Victorian mansion, the dormitory, and constructing the cottage building. The Westover Inn began welcoming guests in 1987.

The Inn has three buildings available for guests. The original Manor boasts five charming second floor guestrooms and one luxurious suite complete with whirlpool. All rooms in the Manor are different shapes with original moldings and 11-foot ceilings. The Manor also houses the Inn's dining rooms, lounge, patio and meeting room. The Terrace, which served as the church's dormitory, sits on a gentle rise overlooking the Manor and holds twelve guestrooms. The Thames Cottage is nestled in the trees and offers privacy and luxury in its two suites and two guestrooms. All of the Cottage rooms overlook the teahouse with its surrounding gardens.

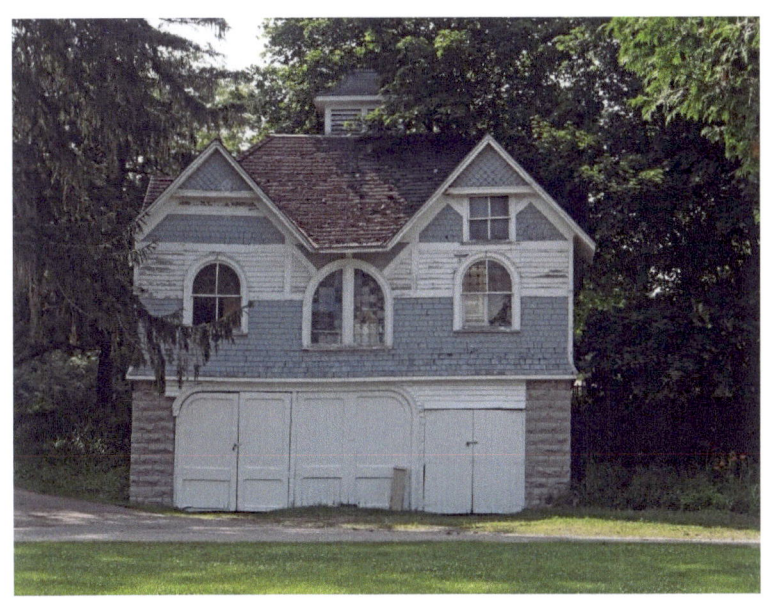

Buildings at Westover Inn

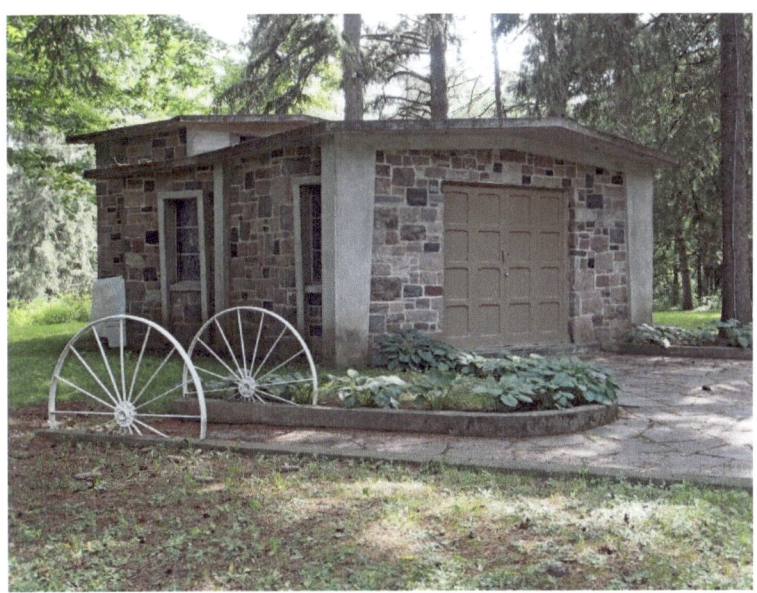

Cobblestone architecture

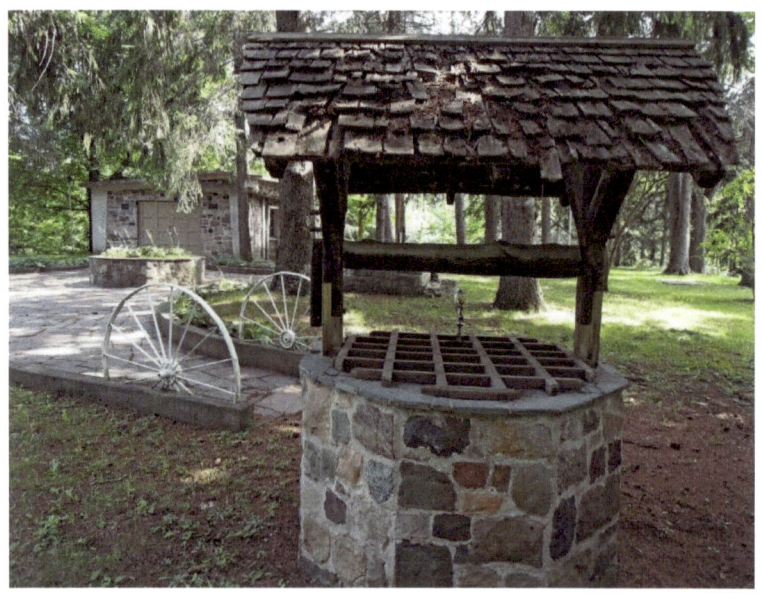

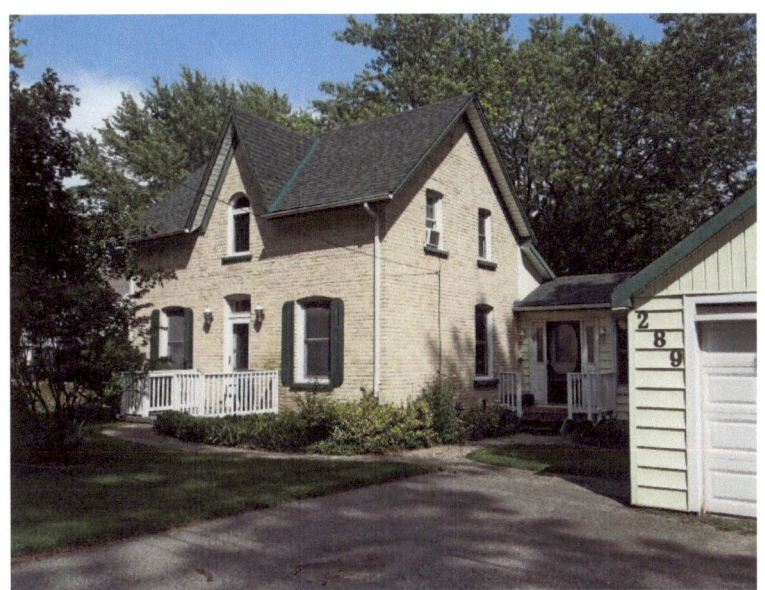

289 Thomas Street – Gothic Revival

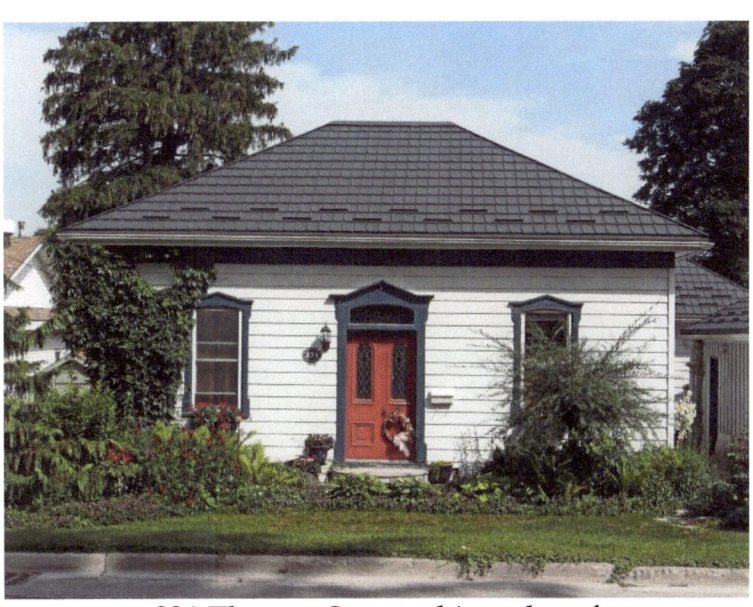

231 Thomas Street – hipped roof

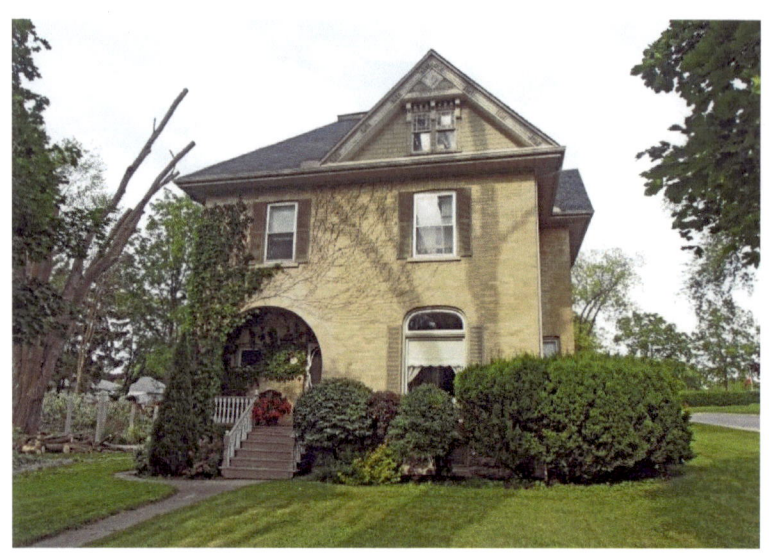

199 Tracy Street – decorative gable – arched entrance

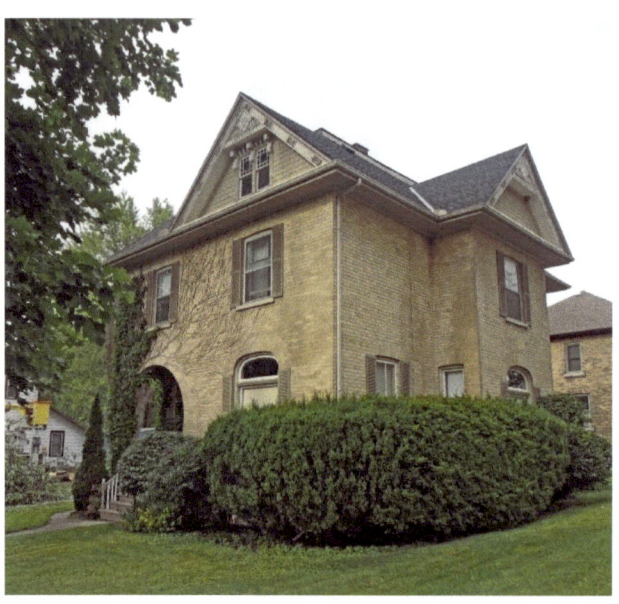

187 Tracy Street

Tracy Street

179 Tracy Street – hipped roof

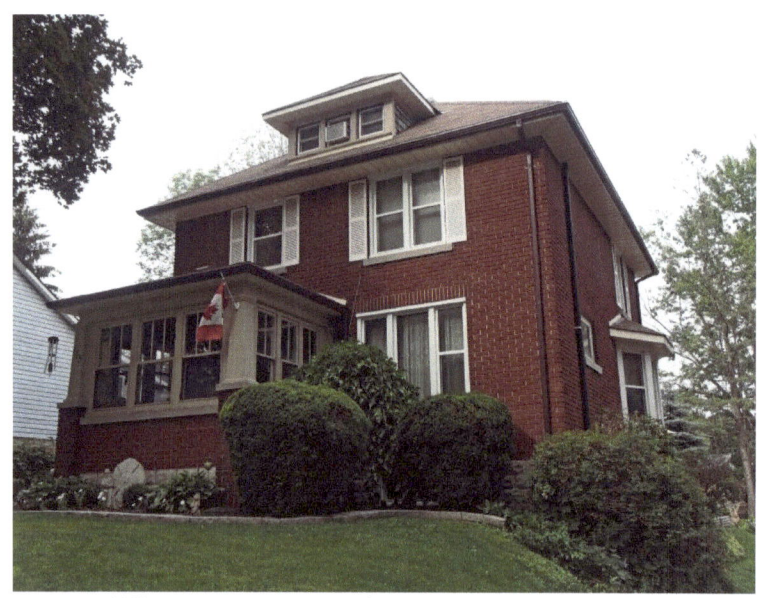

173 Tracy Street – dormer in hipped roof

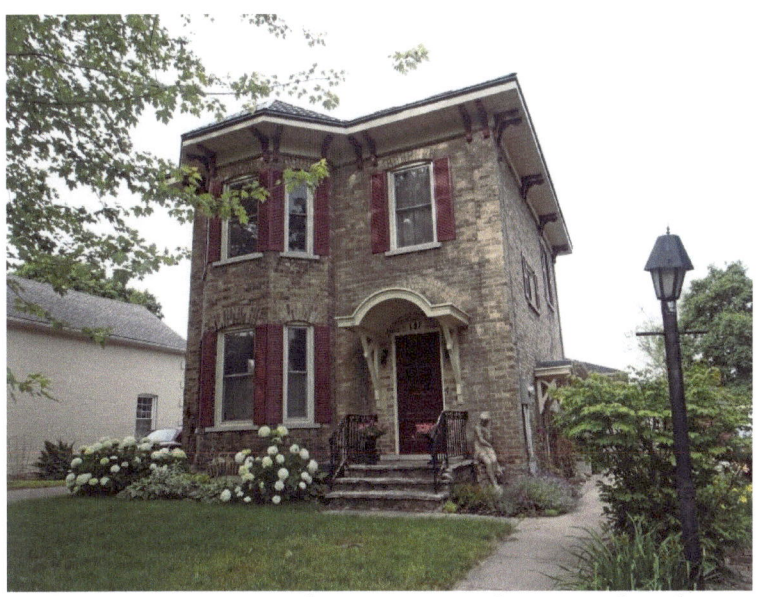

157 Tracy Street – Italianate, paired cornice brackets, two-storey tower-like bay

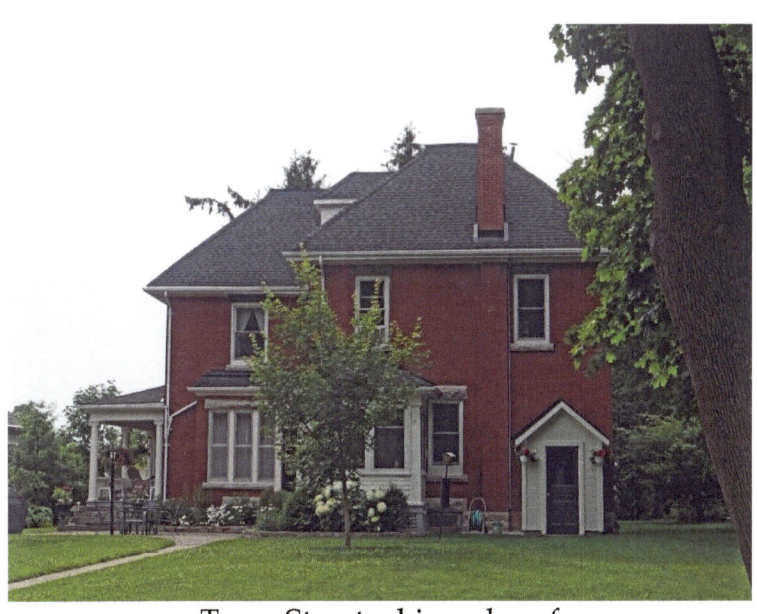

Tracy Street – hipped roof

151 Tracy Street – trim on gable, corner quoins

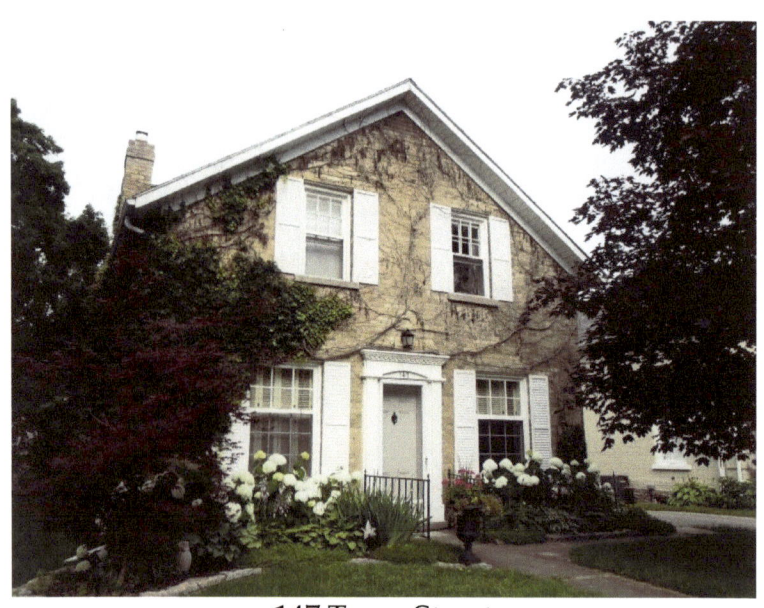

147 Tracy Street

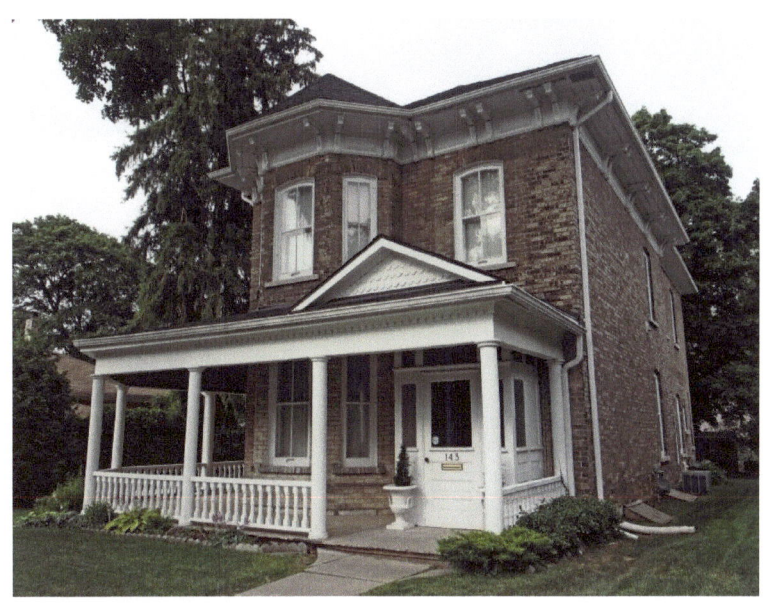

143 Tracy Street – Italianate, two-storey tower-like bay, paired cornice brackets, pediment

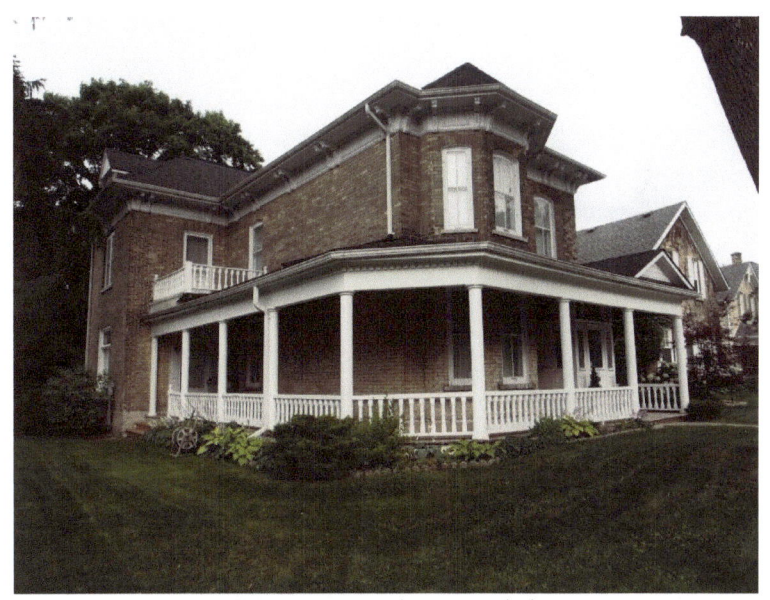

Wraparound verandah

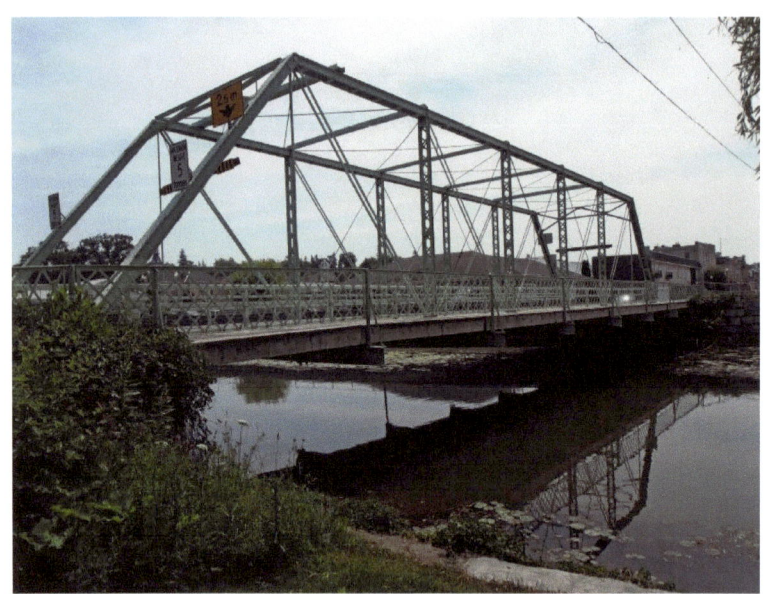

Water Street Bridge

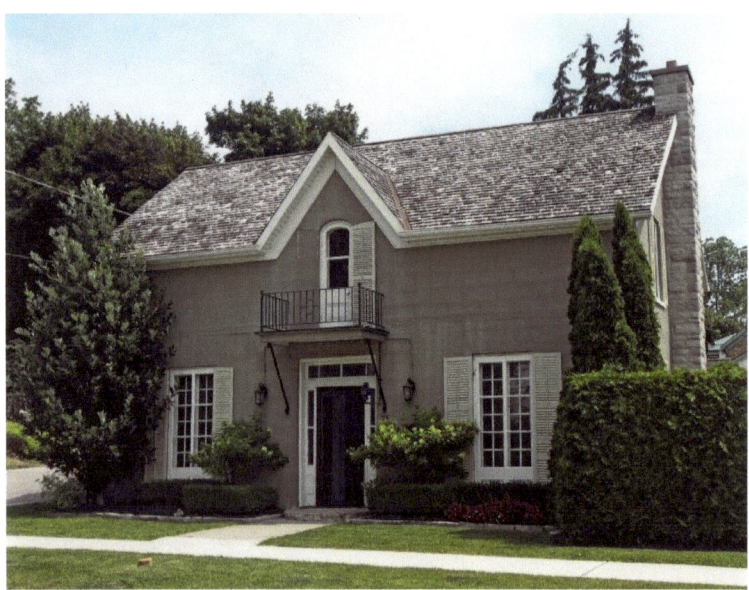

75 Water Street North – Gothic – second floor balcony

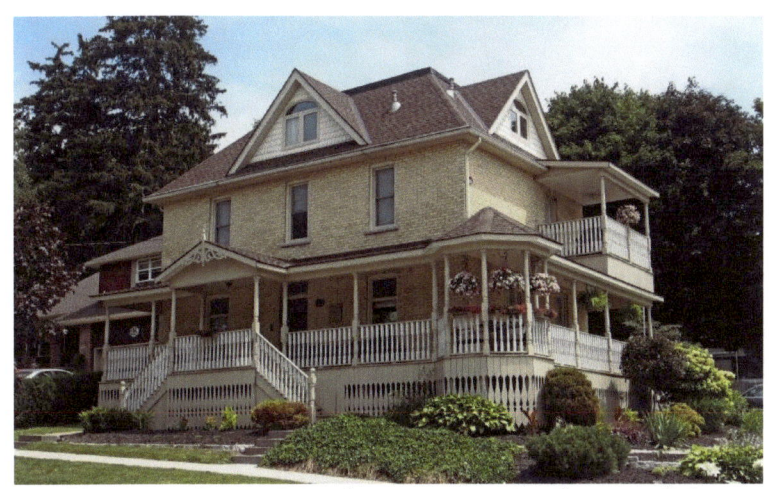

83 Water Street North – wraparound verandah, second floor balcony

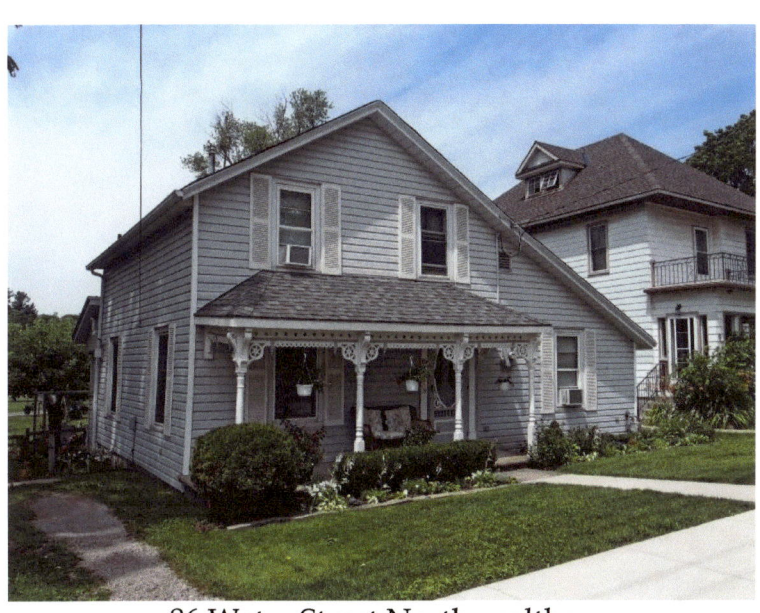

86 Water Street North - saltbox

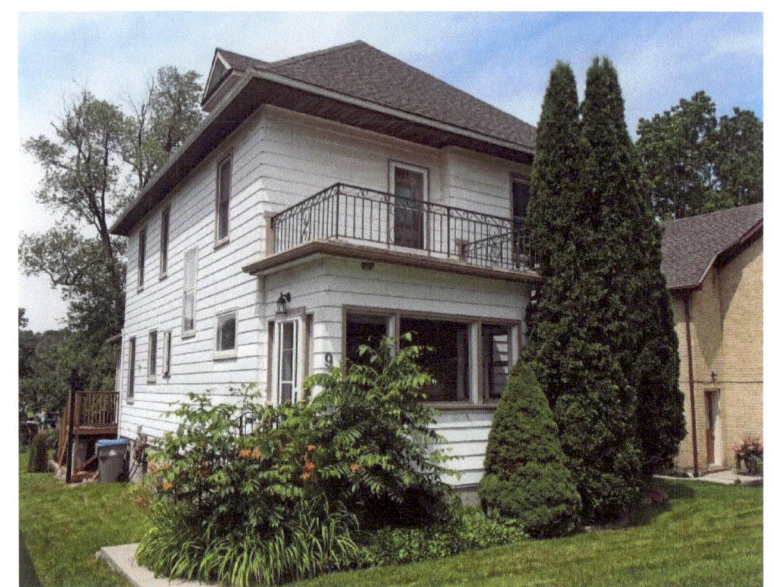

92 Water Street North – second floor balcony, hipped roof

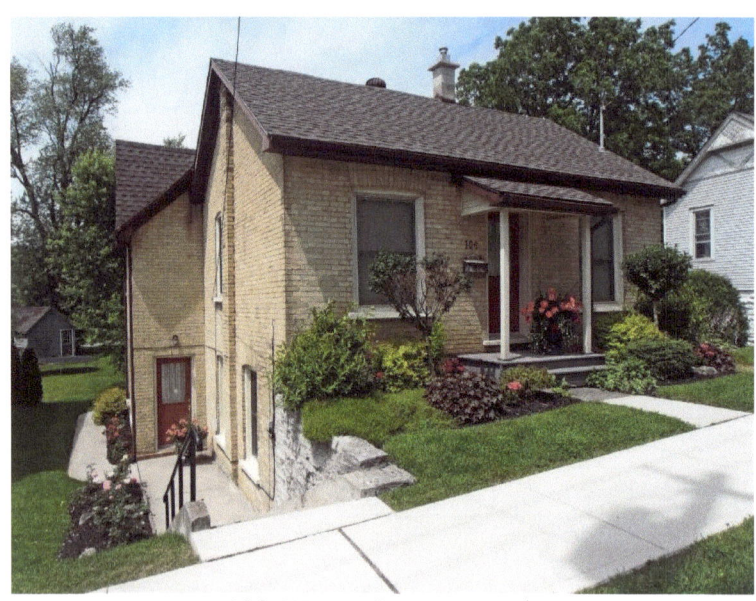

100 Water Street North

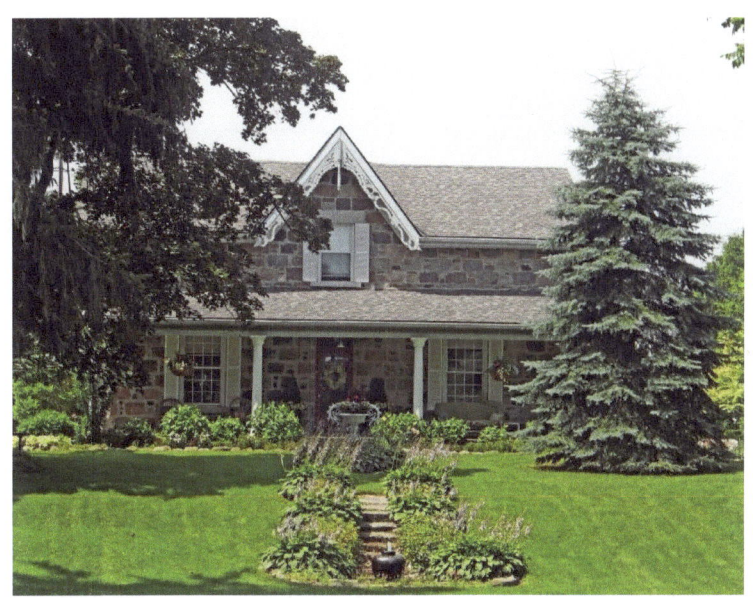

Water Street North – cobblestone – Gothic Revival, verge board trim and finial on gable

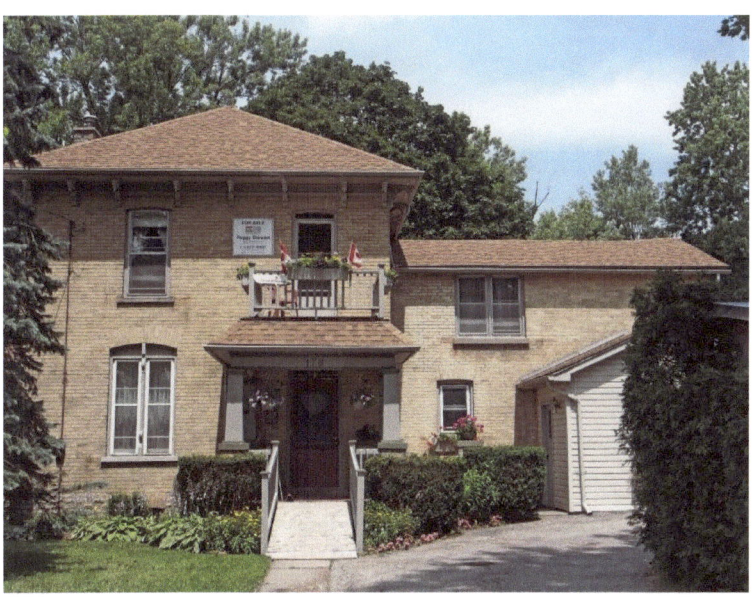

179 Water Street North – hipped roof, cornice brackets, second floor balcony

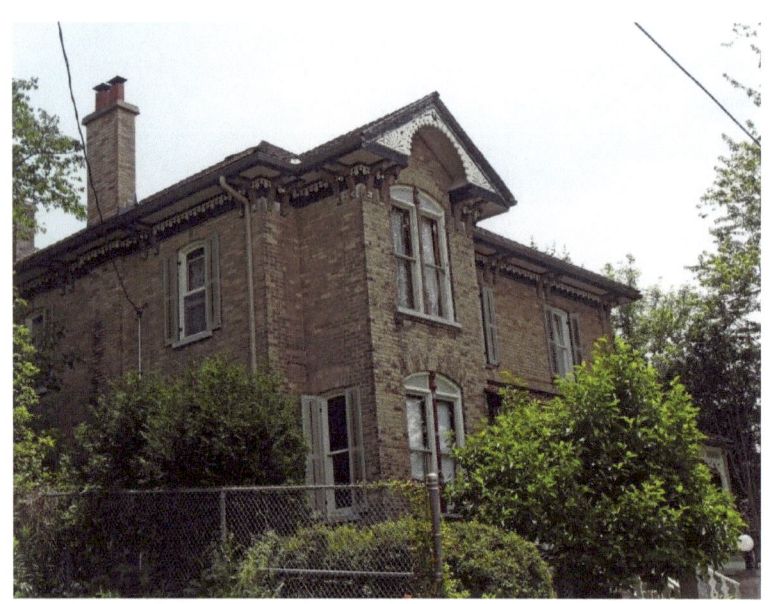

Water Street North – Italianate, cornice brackets

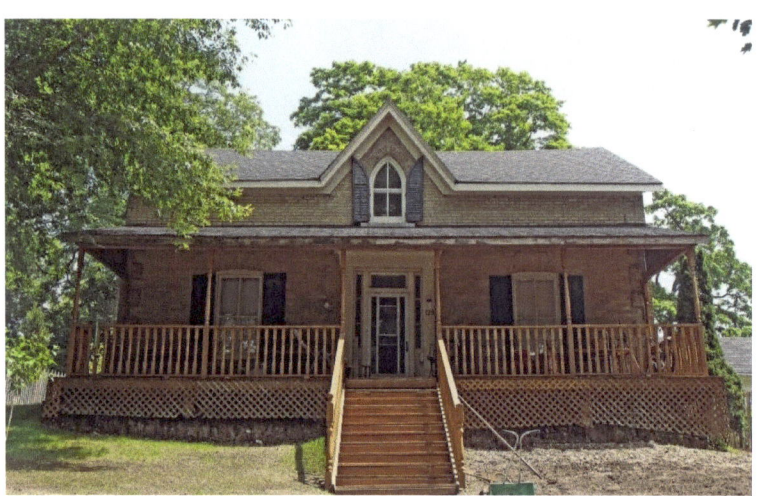

129 Water Street North - Gothic

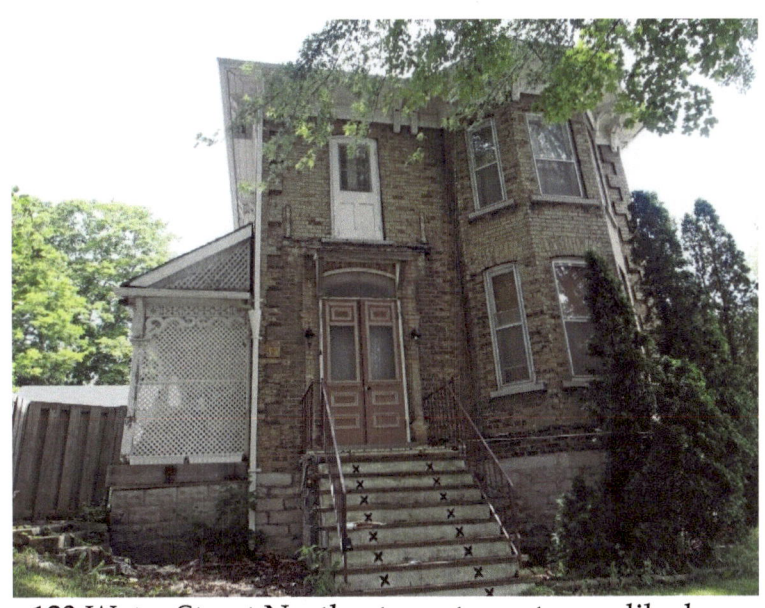

123 Water Street North – two-storey tower-like bay, corner quoins

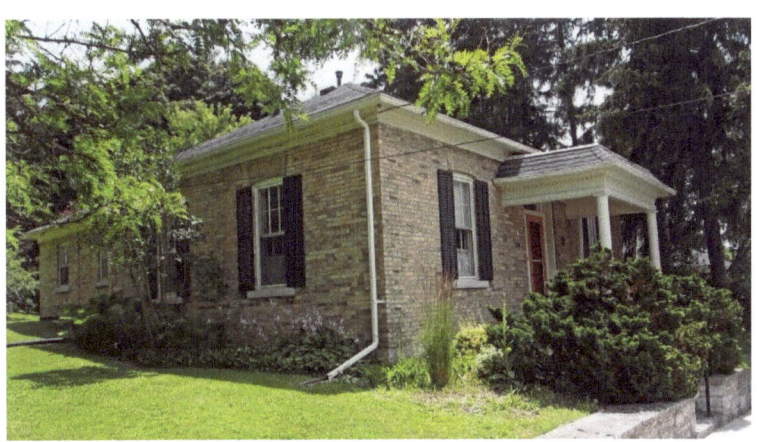

107 Water Street North – 1870 – hipped roof

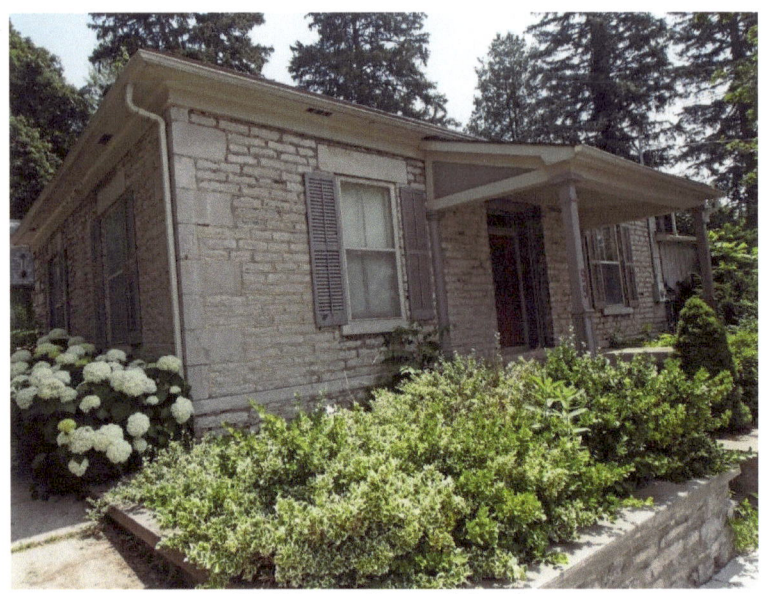

99 Water Street North

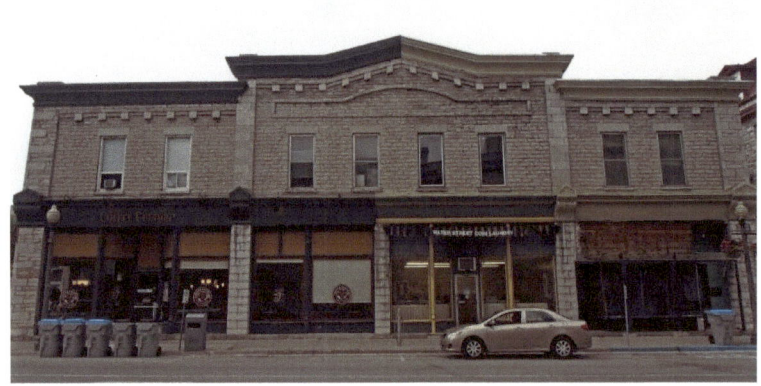

Water Street North – dentil moulding

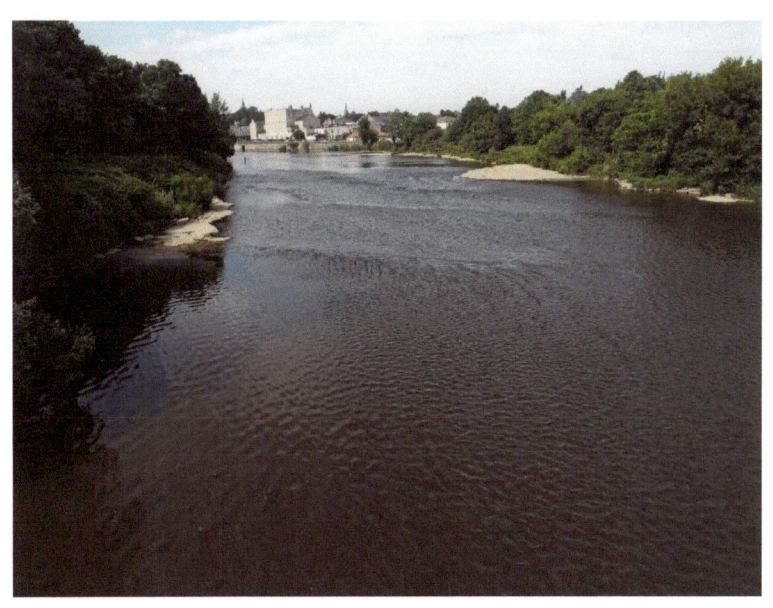

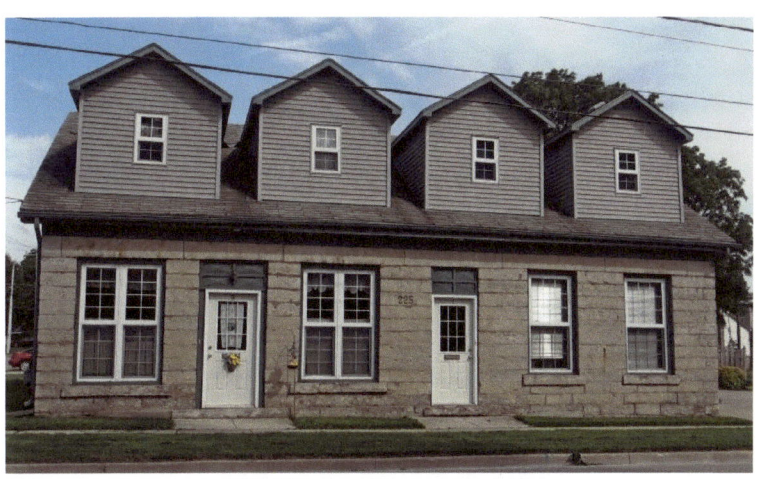

225 Water Street South

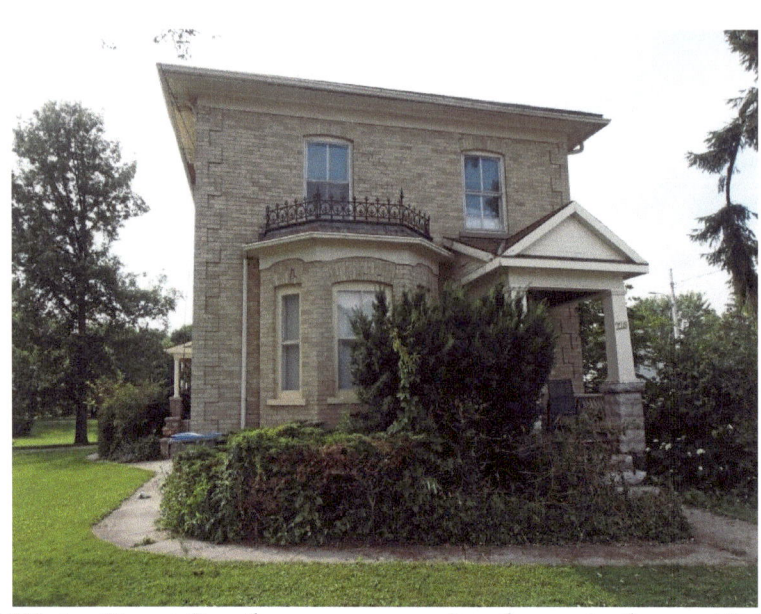

226 Water Street South – corner quoins, bay window with iron cresting above, pediment

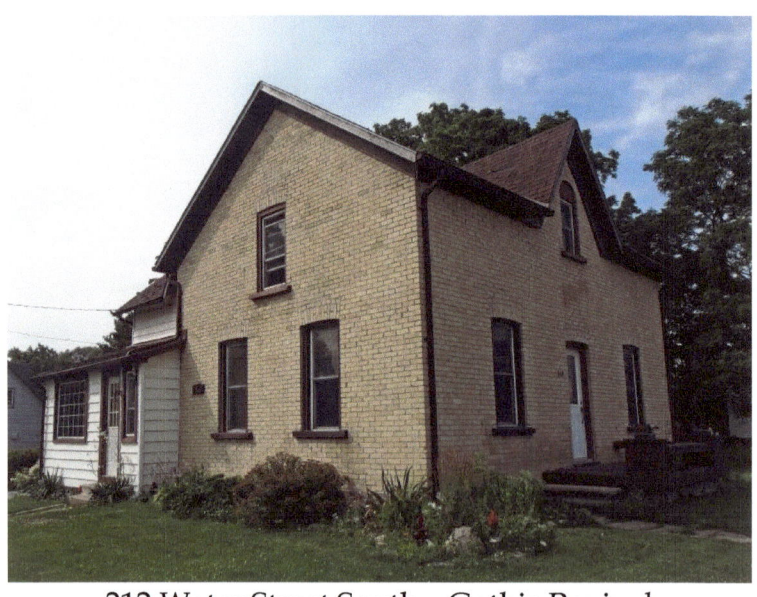

212 Water Street South – Gothic Revival

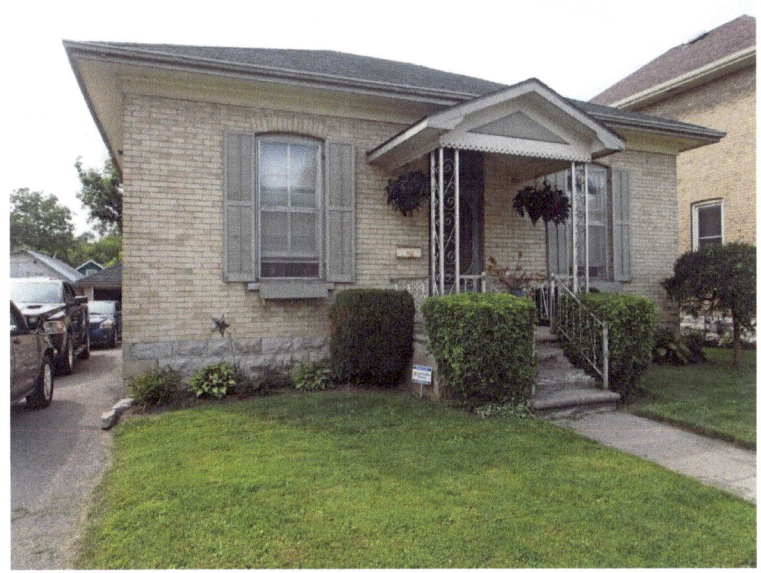
192 Water Street South

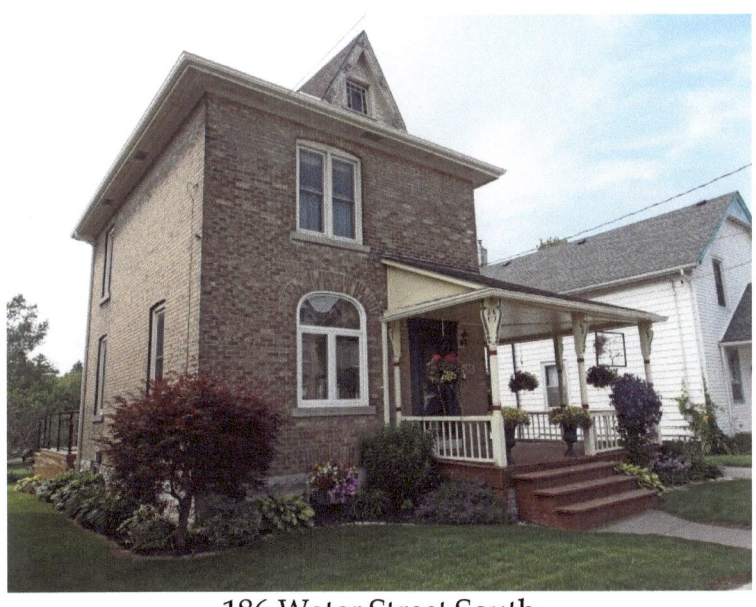
186 Water Street South

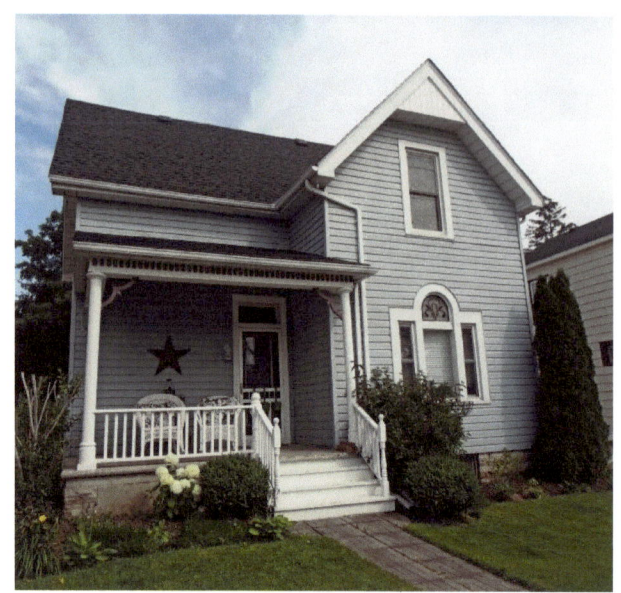

193 Water Street South

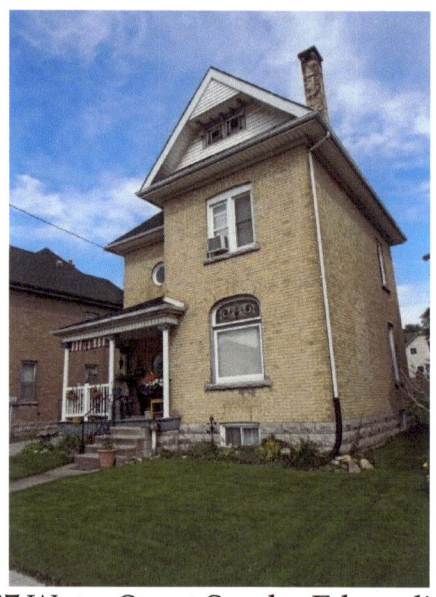

187 Water Street South - Edwardian

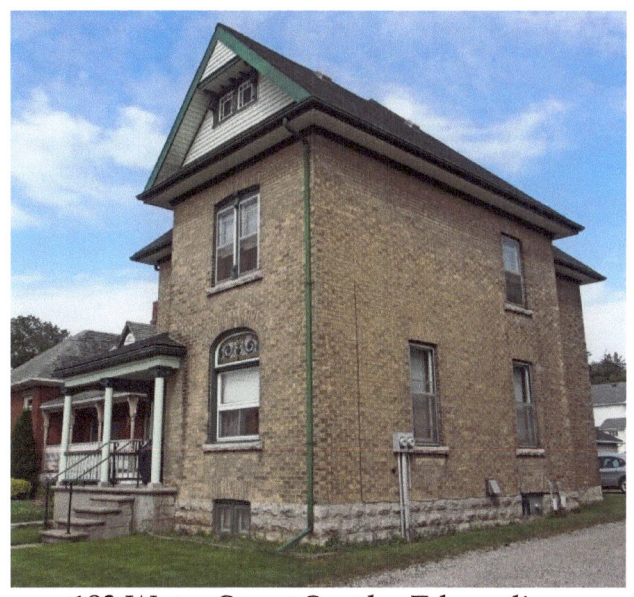

183 Water Street South - Edwardian

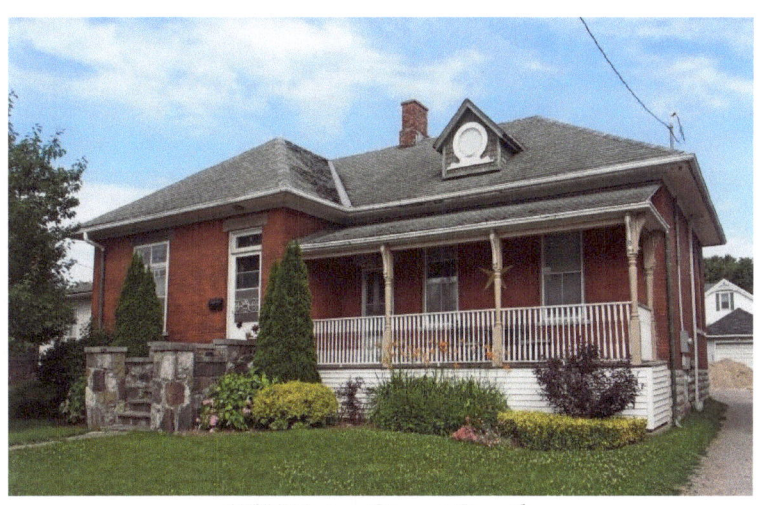

177 Water Street South

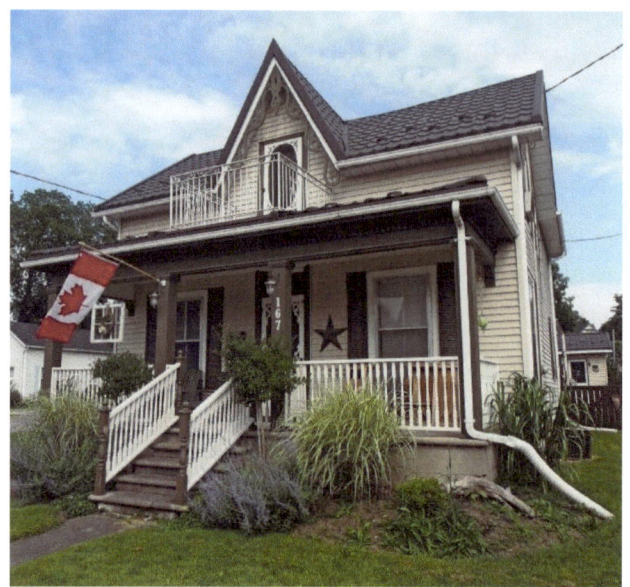

167 Water Street South – Gothic Revival

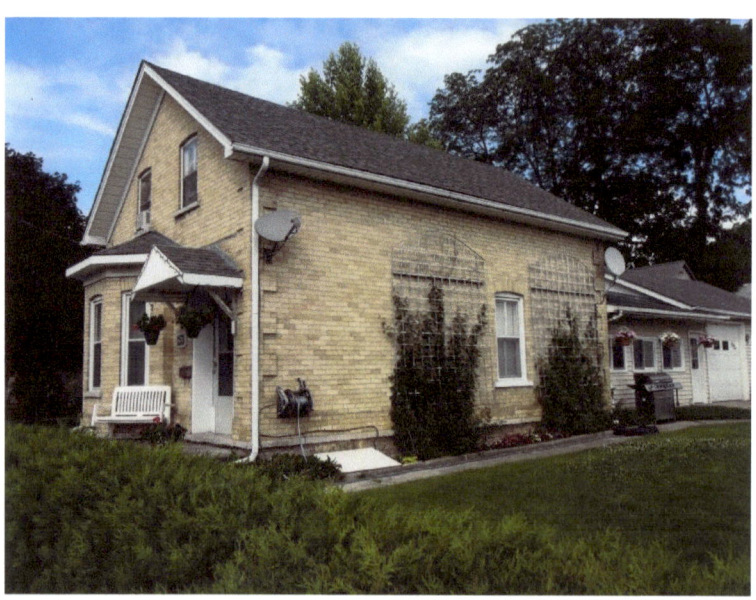

153 Water Street South – Gothic, bay window, corner quoins

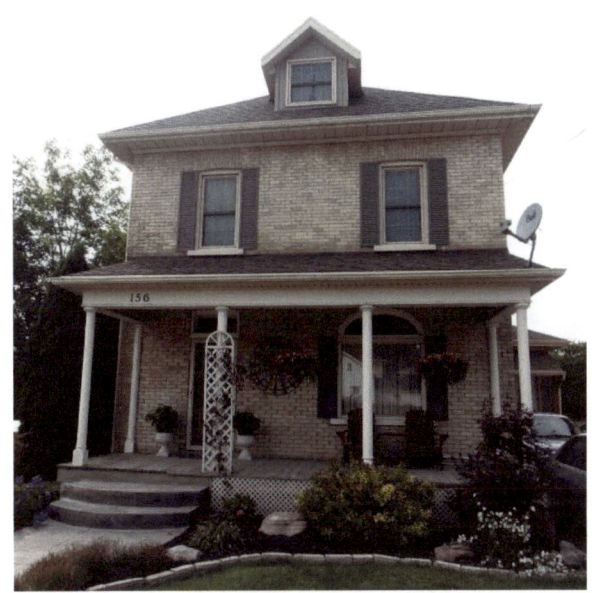

156 Water Street South – hipped roof, dormer

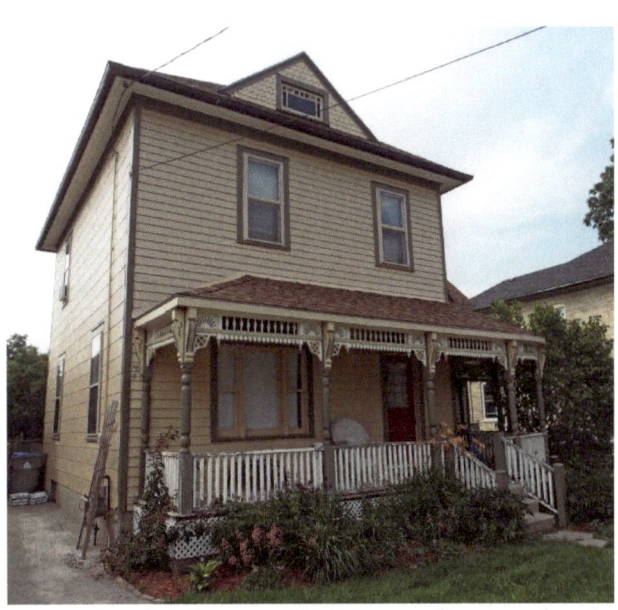

Water Street South – bric-a-brac, stenciling and spindles on verandah

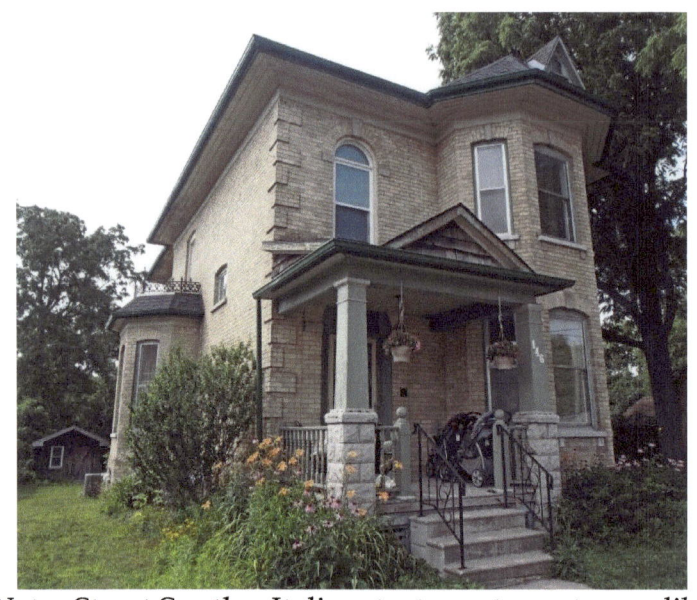

146 Water Street South – Italianate, two-storey tower-like bay, corner quoins, pediment

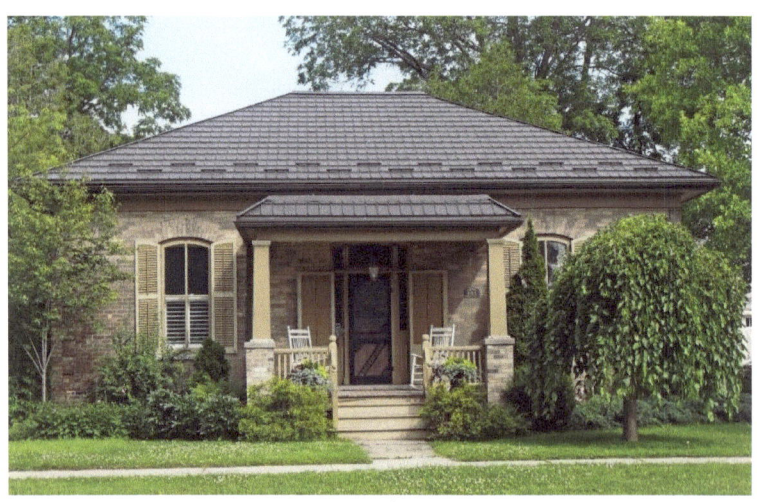

143 Water Street South – Regency Cottage

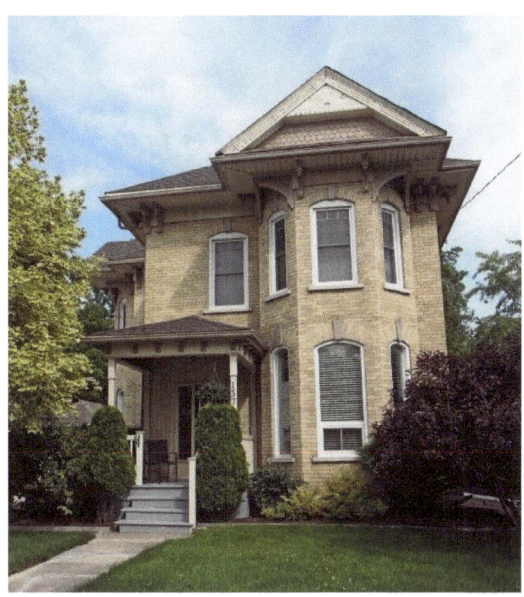

137 Water Street South – Italianate, cornice brackets, fretwork

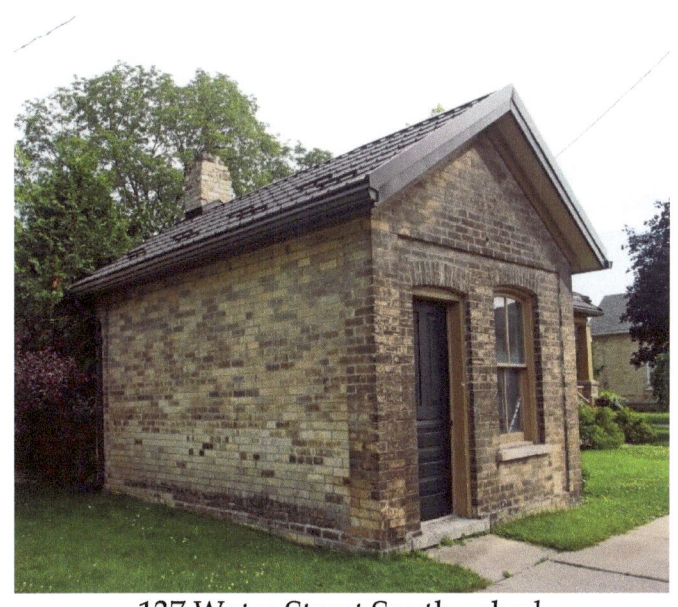

137 Water Street South - shed

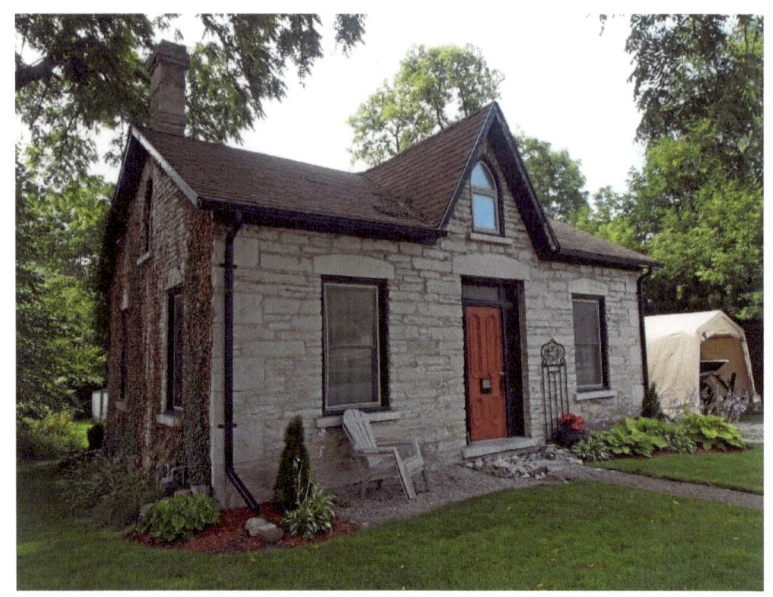

136 Water Street South - Gothic

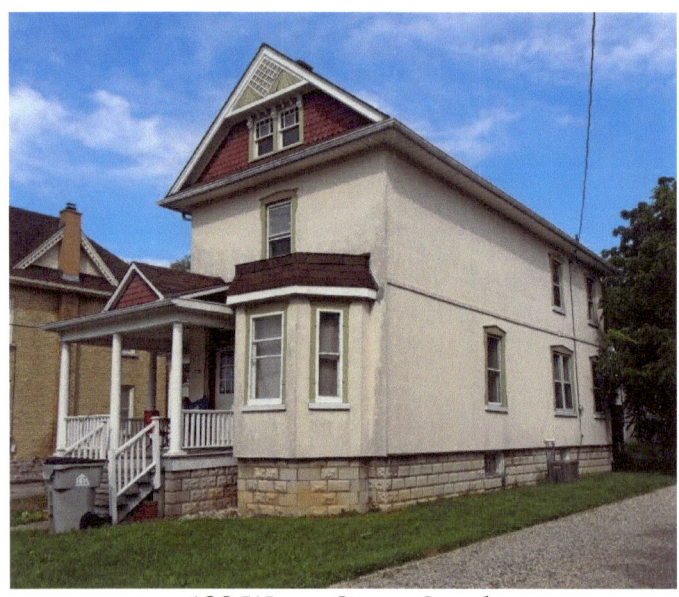

129 Water Street South

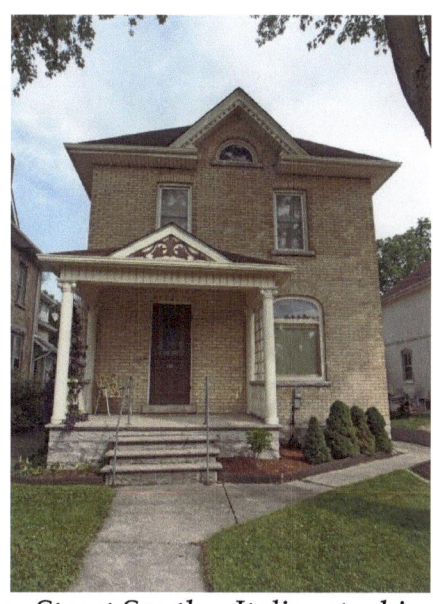

125 Water Street South – Italianate, hipped roof, pediment with decorated tympanum

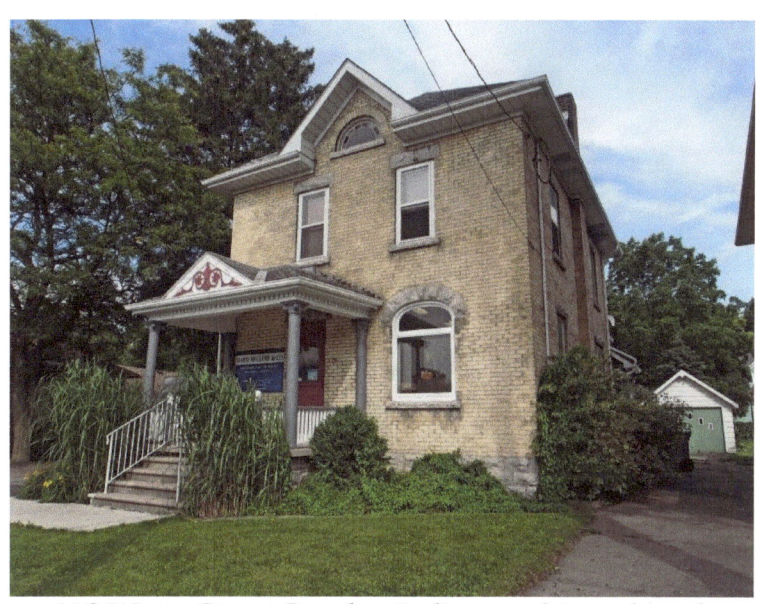

119 Water Street South – Italianate, hipped roof, pediment with decorated tympanum

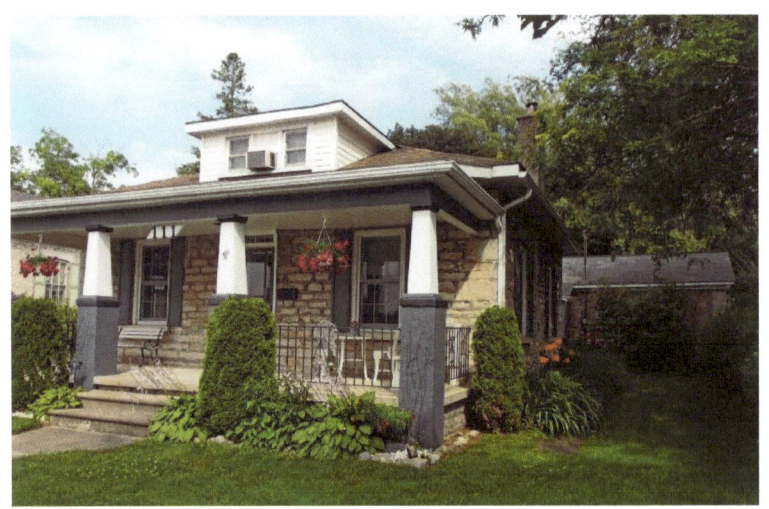

Water Street South - dormer

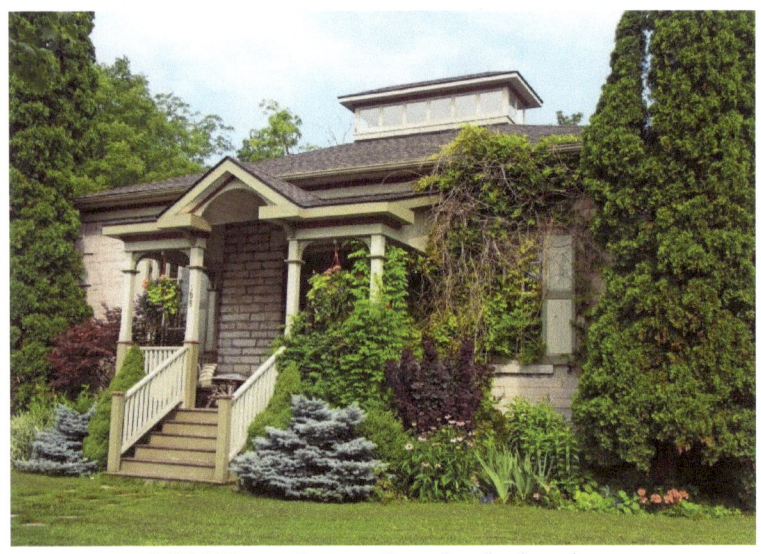

105 Water Street South - belvedere

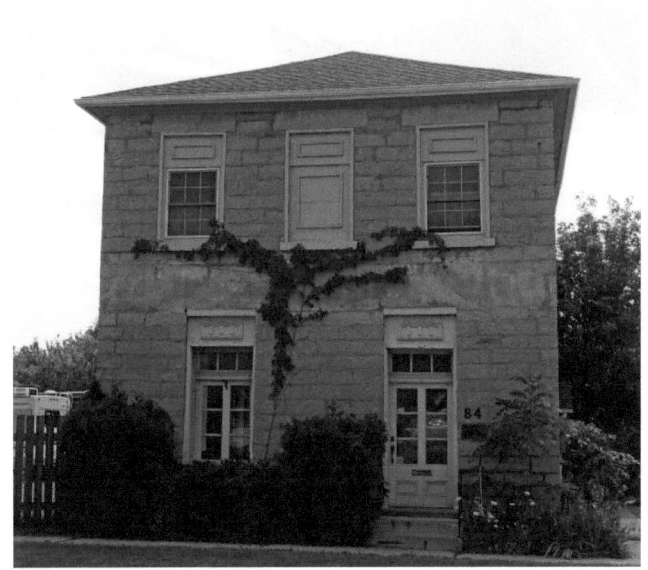

84 Water Street South – hipped roof

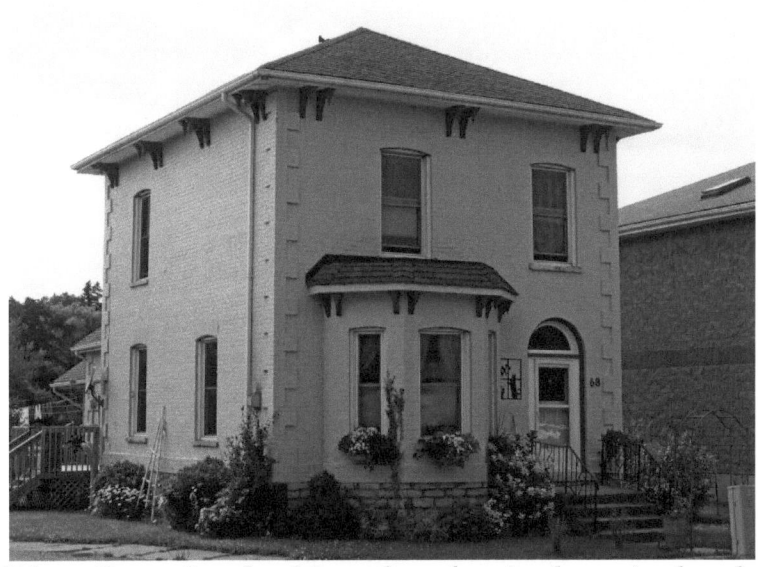

68 Water Street South – hipped roof, paired cornice brackets, bay window, corner quoins

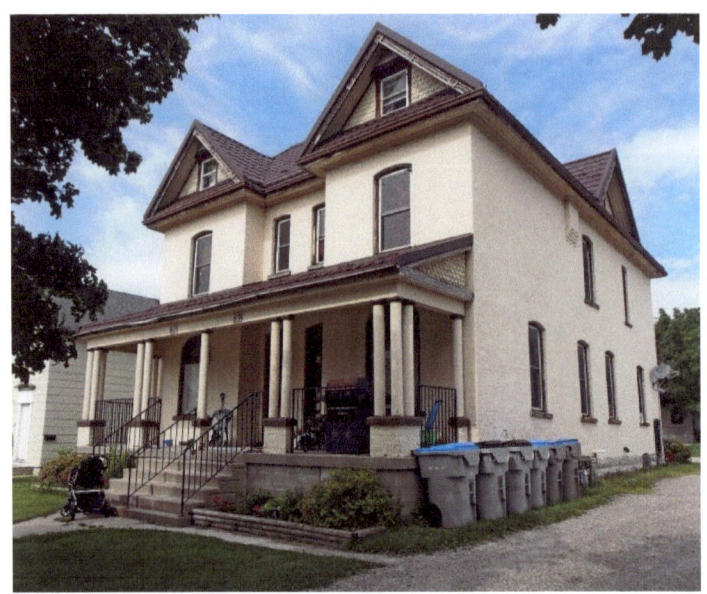

67-69 Water Street South

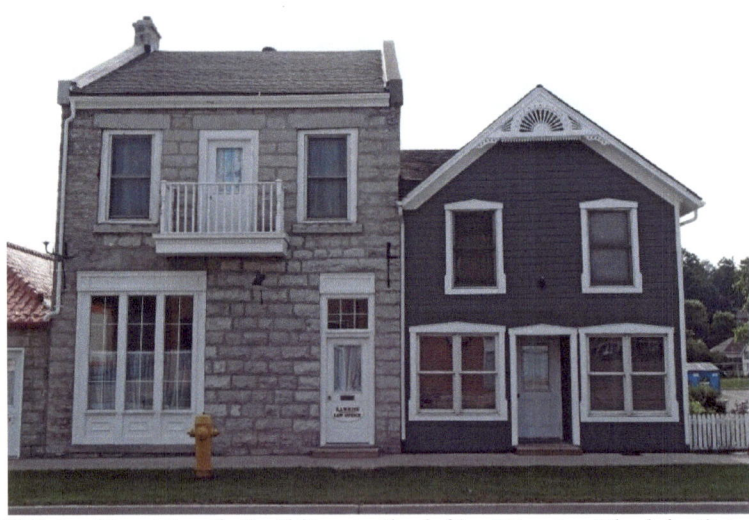

48-50 Water Street South (building to the left) – Dinning Block built in 1857 – James Dinning was a shoemaker; building to right – Lelliot Residence built in 1869 – frame building –
James Lelliot was a plasterer – wooden decoration in gable added at the turn of the century

St. Marys Opera House was constructed in 1879-80 for the St. Marys Lodge of the Independent Order of Oddfellows. James Elliott, the master mason, supplied limestone from his local quarry and lime from his kiln.

Originally the block housed three stores, a concert hall built for an audience of a thousand, and the Oddfellows' temple. In the hall, many travelling troupes performed and local culture and political events were held. Sir John A. MacDonald spoke here on his last campaign in 1891.

The entire block was converted into a flour mill in 1919 and functioned as such for fifty years.

It was built in the Gothic Revival style with turrets, lancet windows, a crenelated roof line, decorative brickwork, and decorative window trimming.

It was restored by the St. Marys Lions Club in 1987.

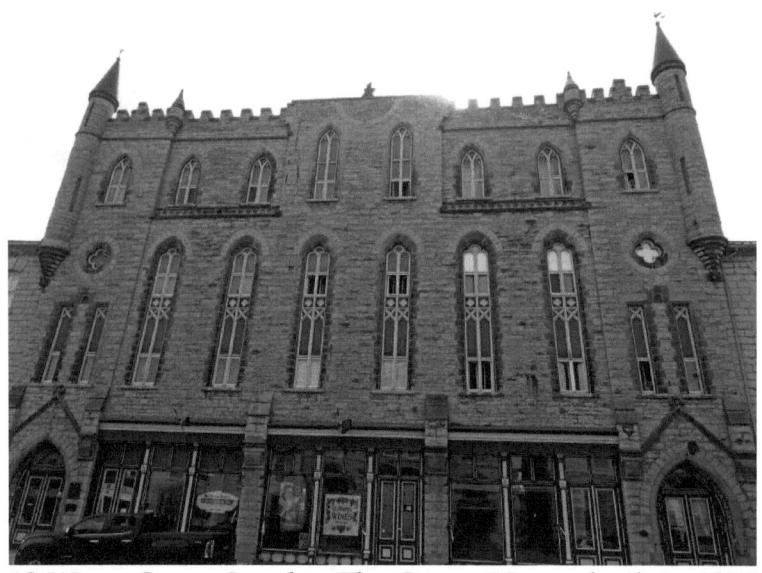

12 Water Street South – The Opera House built in 1879

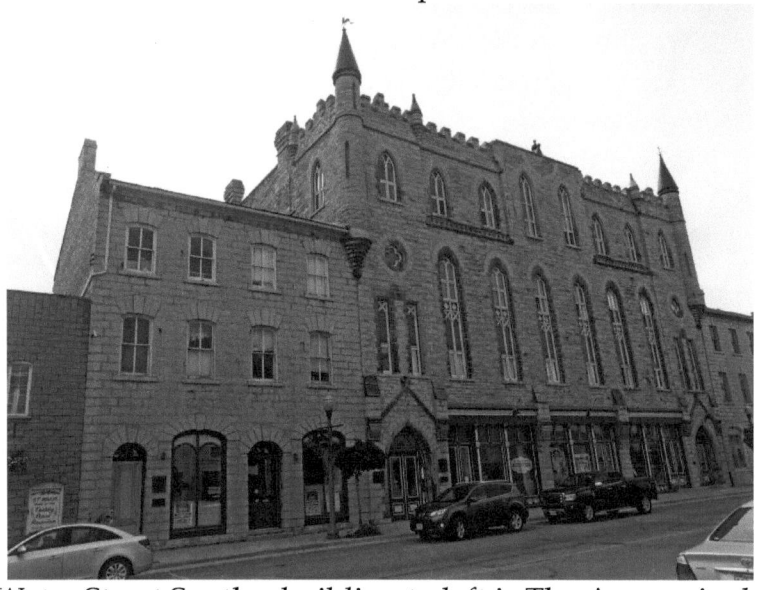

26 Water Street South – building to left is The Armouries built of limestone in 1868 – Italianate style voussoirs with keystones

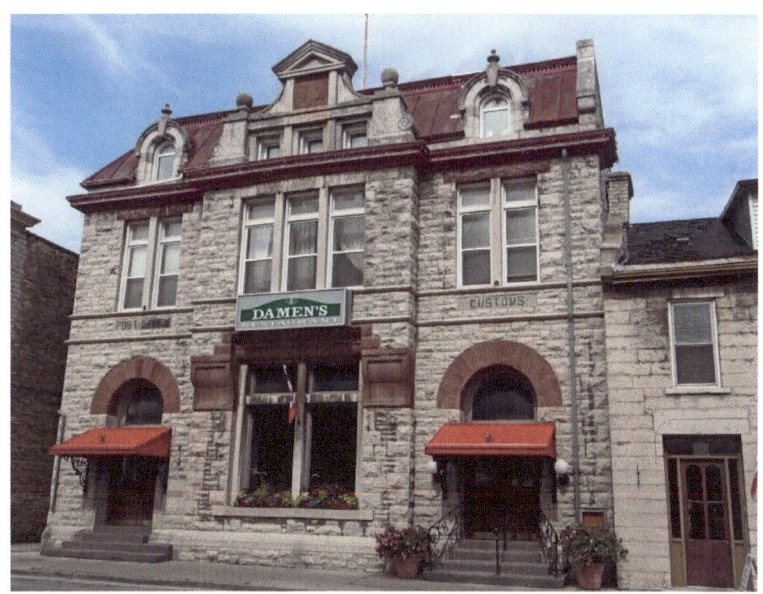

17 Water Street South – The Post Office and Customs House built in 1908 – Romanesque style

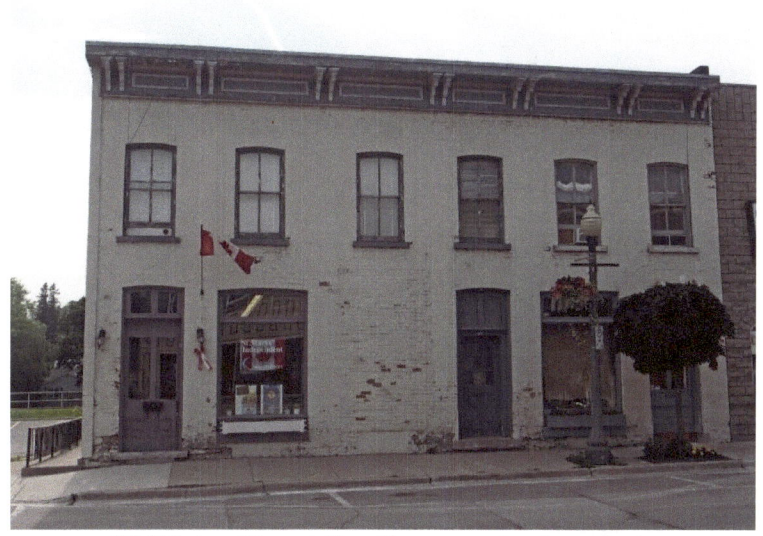

36 Water Street South – cornice brackets

Architectural Terms

Bay Window: A window that projects out from a wall, in a semicircular, rectangular, or polygonal design. Used frequently in Gothic and Victorian designs. Example: 68 Water Street South, Page 49	
Belvedere: (from the Italian "beautiful view") an architectural feature on a roof, in a garden or on a terrace that gives a beautiful view. Example: 105 Water Street South, Page 48	
Brackets: a decorative or weight-bearing structural element which forms a right angle with one side against a wall and the other under a projecting surface such as an eave or roof. Example: 157 Tracy Street, Page 27	
Cobblestone architecture: Refers to the use of cobblestones embedded in mortar as a method for erecting walls on houses and commercial buildings. Example: Westover Inn outbuilding, Page 21	
Dentil Moulding: an even series of rectangles used as ornamental decoration in cornices. Example: 129 Water Street South, Page 34	

Dichromatic brickwork: the use of two colours of brick, tile or slate to decorate a façade. Example: 177 Station Street, Page 15	
Dormer: (French for "sleep") a gable end window that pierces through the plane of a sloping roof surface to create usable space in the top floor or attic of a building by adding headroom. Example: 173 Tracy Street, Page 26	
Fretwork: interlaced decorative design resembling a bracket Example: 137 Water Street South, Page 45	
Gable: the triangular portion of a wall between the edges of a sloping roof. Example: 18 Robinson Street, Page 7	
Hipped Roof: a roof where all sides slope downwards to the walls with no gables. Example: 223 Station Street, Page 13	
Iron Cresting: A decorative ornament along the top of a roof. Iron cresting was popular in the Baroque era and also in Italianate, Victorian, Second Empire and Queen Anne styles of architecture. Example: 226 Water Street South, Page 38	

Keystones and Voussoirs: a voussoir is a wedge-shaped element used in building an arch. A keystone is the central stone that locks all the stones into position, allowing the arch to bear weight. A keystone is often enlarged and embellished. Example: 26 Water Street South, Page 52	
Lancet Window: a tall, narrow window with a pointed arch at its top. Example: 12 Water Street South, Page 52	
Pediment: a triangular section above the horizontal structure (entablature), typically supported by columns. The inside of the triangle is called the tympanum. Example: 119 Water Street South, Page 47	
Quoin: masonry blocks at the corner of a wall, often a decorative feature, usually larger or of a different colour than the rest of the wall. Example: 146 Water Street South, Page 44	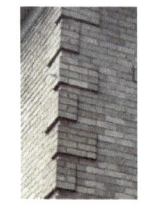

Sidelight: a window, usually with a vertical emphasis, that flanks a door, and is often used to emphasize the importance of a primary entrance. **Transom Window:** the light above the doorway, also called a fanlight. Example: 257 Thomas Street, Page 18	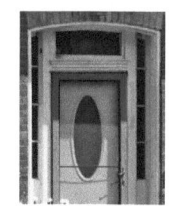
Turret: a small tower that projects from the wall of a building. Example: 12 Water Street South, Page 52	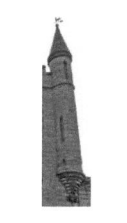
Verge board and Finial: also called bargeboards – hang from the projecting end of a roof and are often elaborately carved and ornamented. **Finial:** ornament added to the top of a gable, pinnacle, canopy or spire – a Gothic element. Example: Robinson Street, Page 9	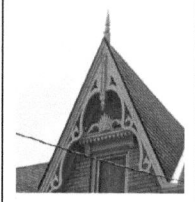

Building Styles

Edwardian, 1900-1930 – This style bridges the ornate and elaborate styles of the Victorian era and the simplified styles of the 20th century. Balanced facades, simple roof lines, dormer windows, large front porches, and smooth brick surfaces are its characteristics. Example: 187 Water Street South, Page 40	
Gothic Revival, 1830-1890 – These decorative buildings have sharply-pitched gables with highly detailed verge boards, pointed-arch window openings, and dichromatic brickwork. It is a common style in Ontario. Example: 75 Water Street North, Page 30	
Italianate, 1850-1900 – It has wide-bracketed eaves, belvederes, wrap-around verandahs. Example: 157 Tracy Street, Page 27	
Regency Cottage, 1830-1860 – This style originated in England in 1815 and spread to Ontario later in the 19th century as British officers retired to Canada. It is a modest one-storey house with a low-pitched hip roof and has a symmetrical front façade. Example: 108 Robinson Street, Page 11	

Romanesque Revival, 1880-1910 – This style hearkens back to medieval architecture of the 11th and 12th centuries with a heavy appearance, blocky towers and rounded arches. Example: 17 Water Street South, Page 53	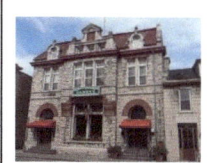
Saltbox: A saltbox is a building with a long, pitched roof that slopes down to the back, generally a wooden frame house. A saltbox has just one storey in the back and two stories in the front. The asymmetry of the unequal sides and the long, low rear roof line are the most distinctive features of a saltbox, which takes its name from its resemblance to a wooden lidded box in which salt was once kept. The earliest saltbox houses were created when a lean-to addition was added onto the rear of the original house extending the roof line sometimes to less than six feet from ground level. Example: 86 Water Street North, Page 31	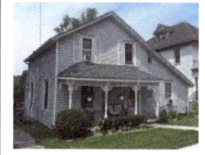
Vernacular/Traditional Mode 1638 - 1950 Influenced but not defined by a particular style, vernacular buildings are made from easily available materials and exhibit local design characteristics. Example: 9 Robinson Street, Page 6	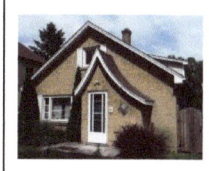

www.ingramcontent.com/pod-product-compliance
Lightning Source LLC
Chambersburg PA
CBHW040853180526
45159CB00001B/408